oræ

Experiences on the Border

T0349709

The Guide

Fabrice Aragno
Mounir Ayoub
Vanessa Lacaille
Pierre Szczepski

prohelvetia
Lars Müller Publishers

oræ, plural of the Latin noun *ora*, translates as "borders" in English. Figuratively speaking, it signifies "the beginning of something."

oræ is a project of a territory, whose setting is its borders and whose authors are its inhabitants. We asked those living on the borders to describe, imagine and build a project based upon their experiences of the territory in which they live. Over two years, hundreds of them worked on it. A "collective intelligence" has been taking shape. This book you are holding in your hands is a guide which chronicles our shared experiences in the making of this project.

Map

Forum I

Pierre-Marie Beth, Bruno Beurret, François Cabraz,
Rolf Gruber, François Pignat, Isabelle Tardio, Massimo Tamone
Great St-Bernard
CH-IT

This mobile forum, conceived as a movable setting for political experimentation, took place in five municipalities that straddle borders. It hosted discussions and collective writing workshops with local residents. Excerpts of these dialogues were then transcribed to be displayed in public space.

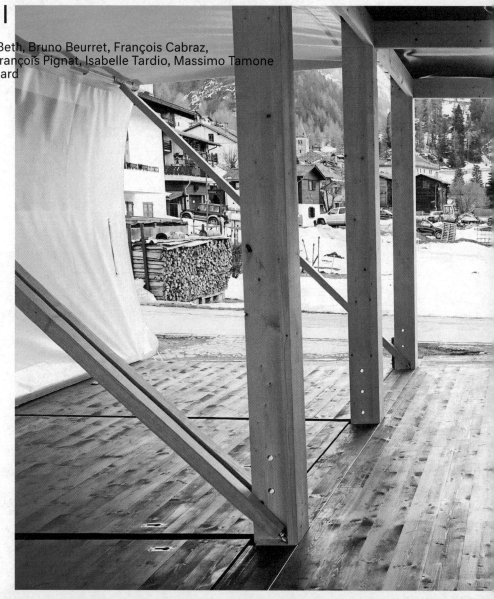

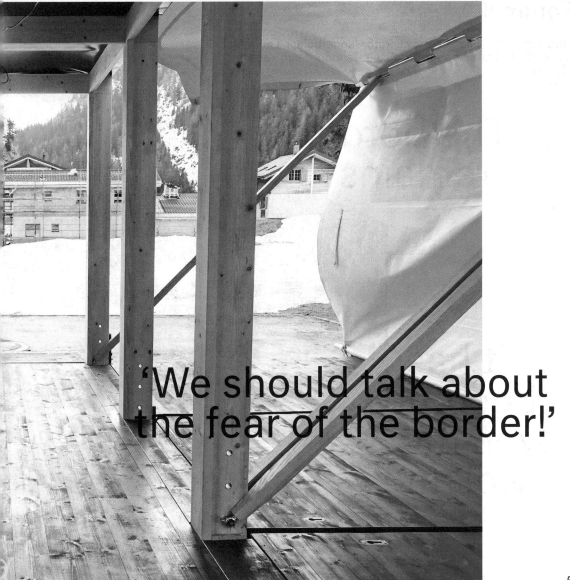

'We should talk about the fear of the border!'

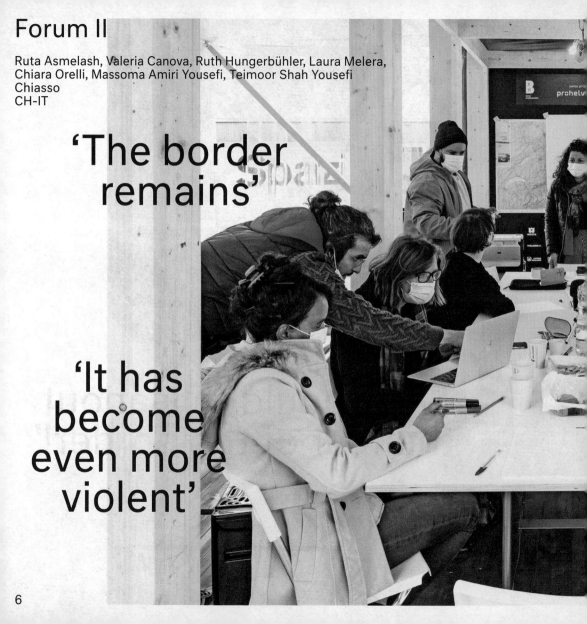

Forum II

Ruta Asmelash, Valeria Canova, Ruth Hungerbühler, Laura Melera,
Chiara Orelli, Massoma Amiri Yousefi, Teimoor Shah Yousefi
Chiasso
CH-IT

'The border remains'

'It has become even more violent'

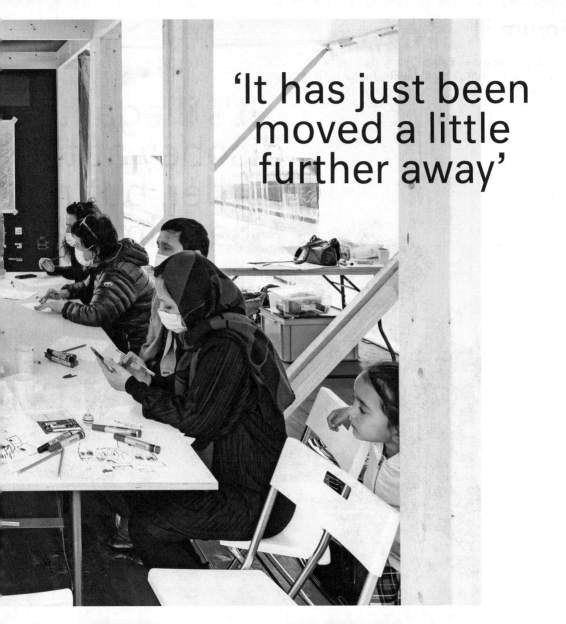

'It has just been moved a little further away'

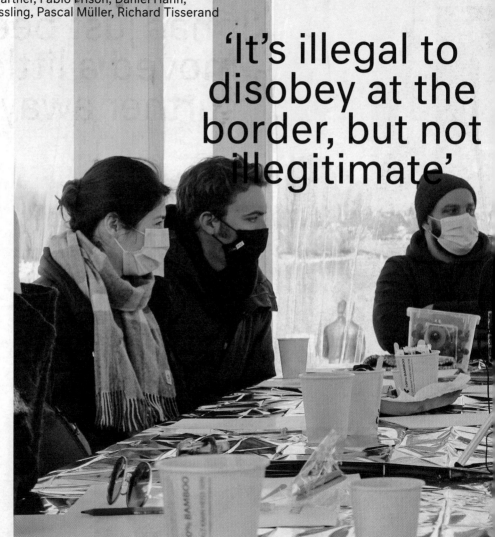

Forum III

Gallus Baumgartner, Fabio Frison, Daniel Hahn,
Jacqueline Kissling, Pascal Müller, Richard Tisserand
Kreuzlingen
CH-DE

'It's illegal to disobey at the border, but not illegitimate'

'We just try
to resist'

Forum IV

Jacques Gubler, Sébastien Le Dortz,
Caspar Schärer, Marc Zehntner
Basel
CH-DE-FR

'Architecture is
directly involved'

'It can underline
or blur borders'

'Yet, borders never disappear; they are redrawn'

Forum V

Uli Amos, Marie Brault,
Matthieu Calame,
Richard Fulop, Isabelle Toumi
Geneva
CH–FR

'At the border,
the other is
always nearby'

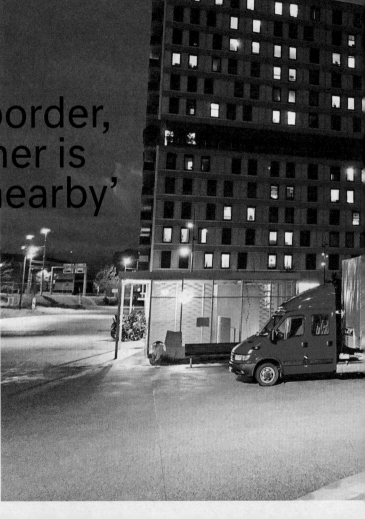

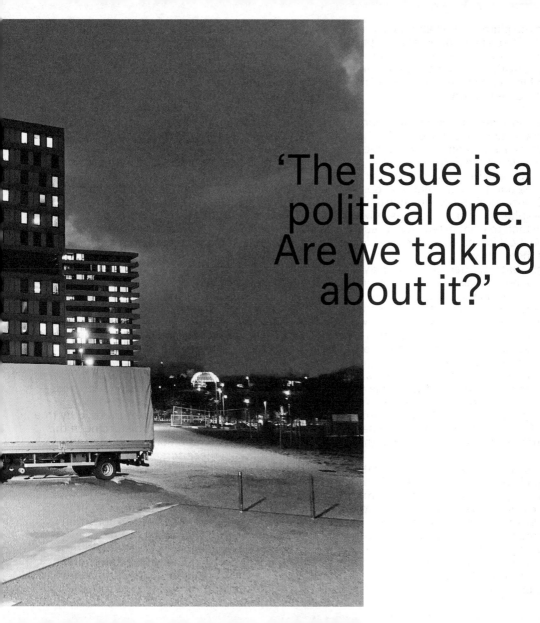

'The issue is a political one. Are we talking about it?'

oræ is the plural of the Latin noun *ora*. In English, it translates as, *inter alia*, "border," "extremity," the "edge" of things or somewhere, or figuratively speaking as the "beginning" of something. *oræ* can also refer to a "region" or a "land": a territory.[1]

Some two years ago, as we were about to embark on this project, we wouldn't for a moment have thought that the issue of borders would ever become the focus of such public interest. Until recently, no one would have imagined that international borders could close so abruptly. One has only to visit the peripheries of nation-states, however, to understand to what extent social, economic and political issues are particularly aggravated there. Most crises we have experienced over the past two decades have played out on national borders, as though they were their favourite stomping ground. Not just the Covid pandemic, obviously, but also the popular uprisings and wars across the Arab world, the election of Donald Trump and Brexit have all reshaped political maps and thus borderlines. The violence accompanying these geo-political sea changes, a violence that has long been the reserve of countries in the global South is now raising its ugly head in the heart of Europe. The pushbacks we're witnessing along Europe's maritime and land perimeters are but the latest abject aspect of this trend.

Borders, however, are as much the theatre of geo-political stakes as they are the space in which daily life plays out for those millions of people living there or who simply cross them on a daily basis. And, depending on who you are, perceptions and experiences of these realities vary greatly. A border as such is neither bad nor virtuous; it primarily hinges upon who it is for. A young Eritrean woman, who participated in the project in Ticino, shared with us

This introduction is the upshot of the presentation of the project to local residents during the winter of 2021.

her fear of borders,[2] a fear which prevents her from approaching them. For a restaurant owner in the Aosta Valley,[3] the recent border closures provoked by the public health crisis have jeopardised her business. The income she used to derive from cross-border lorry traffic between Switzerland and Italy has seen a drastic reduction. A fisherman on Lake Constance never perceived the border on the lake in his daily life until the pandemic made it resurface,[4] for pandemic-related restrictions have led to a reduction of boat traffic on the lake. Whether accepted or endured, the border does impact how people there lead their lives. Hitherto, however, all those concerned did not have their own collective narrative about their home turfs, the worlds they inhabit.

We are convinced that the border is an inhabited territory. The spatial arts and sciences (architects, urban planners, landscape architects) do not consider it as such, however. This might be explained by the equivocal nature of the landscapes one is confronted with there: barbed-wire fences, checkpoints, removal centres for asylum seekers, refugee camps, go slows for cross-border workers, crypto-currency mining farms, casinos, brothels, tax havens, duty free shopping centres. What is disturbing in this detailed enumeration of such places and phenomena, these scrapheaps of unbridled globalisation, is both their agenda and their proliferation within the same territory. To date, the criteria for comprehending these territories have eluded us. For, in contrast to the reassuring representations conveyed by the city and its alter ego the countryside, the border has given rise to, even within these typologies, places that elude conventional spatial categorisations. If the 20th century's natural playground was the metropolis,

borders are now the laboratory for observing and understanding the 21th century's territorial phenomena, and perhaps to take action. For us, as architects, working there has become an obvious necessity.

Our project in the field began with this straightforward question: how deep is the border's impact? By asking those directly living on the border about this, we wanted to question them about the physical reality of their home turf as well as its representation. After teaming up with a filmmaker and a sculptor, we were to spend two years on the road, coming into contact with those living on the border in Switzerland and its adjoining nations; Austria, France, Germany, Liechtenstein, and Italy.[5] Work got underway on a bridge crossing the Rhone near Geneva, where we asked a couple with a child, who live in France and work in Switzerland, to describe their daily experiences of the border.[6] This couple depicted it as a paradoxical place, entangled within several administrative, social and imaginary borders, a complex setting encompassing passages as well as ruptures. We then invited them to build a model of their day-to-day world and to take us to the places they had modelled. We filmed the whole experience. What was striking was the contrast between the territory made in the model and their "real" home turf. This first encounter truly confirmed that the (border) line is, in fact, an inhabited space. The model in front of our eyes functioned as a three-dimensional diagram which at once accurately portrayed the relationships between residents and the space in which they navigate their lives. If the model allowed us to visualise the inhabitants' imaginary world, then the video enabled us to approach them more directly and to capture their emotions.

We further continued this experimental approach throughout Switzerland, seeking to improve it at every stage. Over time, the project was to become a kind of collaborative, multidisciplinary border laboratory. Several colleagues, who were specialists in in video-making, joined us in this endeavour, as did some others experienced in model-making, mediation and the visual arts. In all, we travelled more than 9,000 kilometres, across five adjoining countries, twenty-four cantons and 224 municipalities, in a truck we converted into a model- and video-making workshop. Some two-hundred people were involved and more than eighty inhabitants actively participated in the project. Together, we discovered countless places, some in the most unlikely of settings. About fifty models were made. We spoke, or tried to do so at least, in Switzerland's four national languages, French, German, Italian, and Romansch, as well as in English, Arabic, and Farsi. We recorded thousands of hours of video.

Of greater importance than those figures and data were our shared experience of the border with those living it day-in day-out. The sailor operating a ferry on Lake Constance provided us with the definition of a "condominium," a highly specific legal status applied to lakes and rivers.[7] As such, no border lines run through Lake Constance. Instead, the three bordering countries, Austria, Germany, and Switzerland, exercise joint sovereignty. This legal status serves as a timely reminder that there are other forms of governance which are not necessarily based on shared territory. On the eastern rim of Switzerland, on its border with Austria, the leader of the small municipality of Samnaun told us how their village[8] has become some kind of open-air duty free shopping centre by taking advantage

of its status as an enclave. His testimony raises pertinent questions about financialization mechanisms in certain border regions. On the Italian border, the owner of an inn told us about the construction of the Lago di Lei dam.[9] At this spot, the border line deviates in order to encompass the infrastructure on Swiss territory, whereas the watershed is entirely in Italy. The border line thus follows strategic national energy issues. In Ticino, asylum-seeking residents were unable to describe the Swiss border to us,[10] for they are not allowed to go anywhere near it. They spoke to us of borderlands in Iran, Afghanistan and Eritrea. They reminded us that, for many, borders still function as walls. Finally, as a last example amongst multiple others, a painter from Stein am Rhein let us know about the Grüne Grenze,[11] a forested area straddling borders that is difficult to monitor, which thus enables smugglers, human-traffickers and migrants to cross international borders without being detected. His account serves as a reminder of the tensions and sometimes the hatred that exist between those longing to cross borders and those in charge of guarding them. We tend to forget that the border also operates as a surveillance device. All these testimonies lay bare intensely paradoxical feelings. Hence, at times the border device provokes a desire for insubordination, or even disobedience, in those who live alongside it. The question of the legitimacy and territorial governance of states on borders is being questioned, commandeered by those living there. Often, the border acts as a rallying call to resist.

After seven months of "touring," we then started on the protracted surveying process, both in the sense to reproduce through drawing that which is already there, the visible, and to highlight what is hidden, the invisible. Each discussion was initially transcribed and then translated. The images were viewed, selected, and ultimately edited. The models were measured and positioned. The shapes, textures, colours and writings were reproduced in drawings. Gradually, we were able to lay the foundations for a formal lexicon combining reality and imagination. From this language, we could then build a large collective model and drew a new map. The model and the map are as much representations of a given territory as they are of its implementation. An open, landscape appeared before our eyes, rather than a sense of order. The volumes, the images, the words mapped out a kind of mundus imaginalis comprising fragments of borders.[12] They form a multiplicity of objects and discontinuous discourses. Juxtaposed, they sketch out a borderless carpet, invariably fragmentary, unfinished. There's no starting point, no end point, always a beginning, then another. On the border, relationship to things is of greater importance than the things in themselves.

During the late winter of 2020, the onset of the Covid pandemic turned our worlds upside down. Overnight, borders were to become a burning issue worldwide. The stories we had collected up to that juncture immediately acquired an additional level of meaning. No longer did they merely reflect personal experiences within a given territory, but rather became invaluable testimonies about a territory in the throes of change. Though this public health crisis triggered stringent restrictions on freedom of movement and a tightening of security around borders, we nonetheless were determined to continue our project by going back on the road again. Our truck was transformed into a mobile forum.[13] We thought of it as a nomadic space, light, joyful and welcoming to the public. It travelled

to five border municipalities and was deployed in public spaces in order to offer a place for discussion and collective writing workshops with those same residents who had participated in the project's initial phase. This forum was conceived of as a place where that public thing, namely the border, could be openly debated. Gradually, a collective intelligence, *a res publica*, began to take shape. That which is on the margins becomes the beginning of something, a place.

By arguing that the border is a territory inhabited by those living there, this project invites a radical transformation of how we evaluate it on multiple levels. First, it proposes that we rethink the border as a place in its own right, with its own specific issues, representations and complexities, so that those living there can construct their own collective narrative. In turn, by learning from the border, it becomes a gauge with which to see and understand current territorial issues, for scrutinising the contemporary world from its own margins. While this last reverse gaze, as advocated by this project, is the most challenging, it is also perhaps the most imperative. It invites us to rethink the border not as a device with which to defend our identity and to pit us against each other, but rather as a place for expanding otherness through difference, as a territory abounding in inter-relationships and passages. In a hyper-contemporary world, increasingly built around the re-emergence of identity politics and partisan desires for compartmentalisation, the border, paradoxically, could potentially become a place for resistance. This is what we learnt from the people living on the border.

1 As defined in a Latin–French dictionary *Gaffiot*, pp. 1088-1090 and *Lebaigue* p. 869.

2 Ruta Asmelash was an asylum seeker in Switzerland before obtaining her residency permit. She participated in the project in Lugano and later in Chiasso.

3 Isabelle Tadio is a restaurant owner. She participated in the project at Saint-Rhémy-en-Bosses and later at Bourg-Saint-Pierre.

4 Gallus Bamgartner is a fisherman on Lake Constance. He participated in the project in Altenrhein and later in Kreuzlingen.

5 Our team comprises the architect and landscape architect Vanessa Lacaille, the architect Mounir Ayoub from Laboratoire d'architecture, as well as the filmmaker Fabrice Aragno and artist sculptor Pierre Szczepski. The video-artist Annabelle Voisin, the mediator Benoît Beurret and the architects Noémie Allenbach and Jürg Bührer also actively participated in the project.

6 Marie Brault is a market gardener. Richard Fulop is an architect. They participated in the project in Geneva. Richard Fulop, the first local resident to participate in the project, later became the president of the Association of Swiss Border (s) who has been working on this subject for two years.

7 Pascal Müller works on the ferry that crosses Lake Constance. He participated in the project in Romanshorn and later in Kreuzlingen.

8 Walter Zegg is leader of the commune of Samnaun.

9 Valentino Del Curto runs an inn at Lago di Lei.

10 Yaqoob Abed, Teimoor Shah Yousefi and Massoma Amiri Yousefi are asylum-seekers. They participated in the project in Lugano and in Chiasso.

11 Richard Tisserand is a painter. He participated in the project in Stein am Rhein and later in Kreuzlingen.

12 Derived from the Arabic *âlam al-mithâl,* it translates into English as the "world of the imaginary and imaginal."

13 We conceived our mobile forum mobile in tandem with students from the Bern University of Applied Sciences. Professor William Fuhrer, assisted by Jürg Bührer, directed the pedagogic exercise and the subsequent conception and realisation of the project.

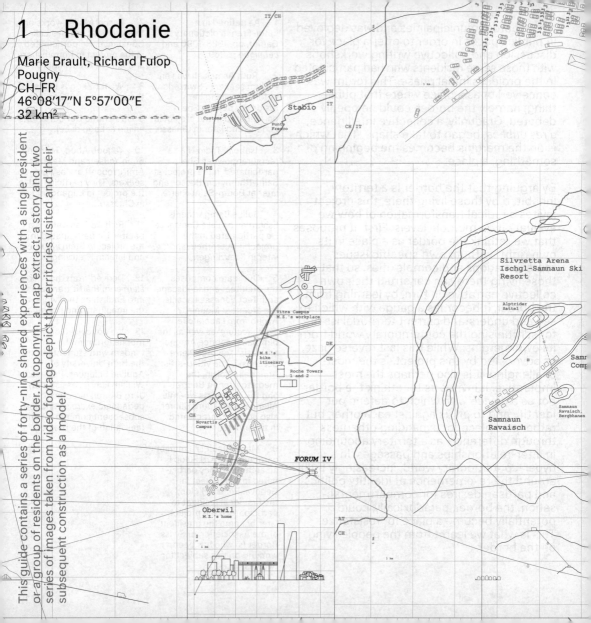

1 Rhodanie

Marie Brault, Richard Fulop
Pougny
CH–FR
46°08′17″N 5°57′00″E
32 km²

This guide contains a series of forty-nine shared experiences with a single resident or a group of residents on the border. A toponym, a map extract, a story and two series of images taken from video footage depict the territories visited and their subsequent construction as a model.

Stabio

Customs
Punto
Fresco

IT CH

CH
IT

CR IT

FR DE

Vitra Campus
M.Z.'s workplace

M.Z.'s
bike
itinerary

Rocha Towers
1 and 2

DE
CH

FR
CH

Novartis
Campus

FORUM IV

Oberwil
M.Z.'s home

AT
CH

Silvretta Arena
Ischgl-Samnaun Ski
Resort

Alptrider
Sattel

Samr
Comp

Samnaun
Ravaisch

Samnaun
Ravaisch,
Bergbhanen

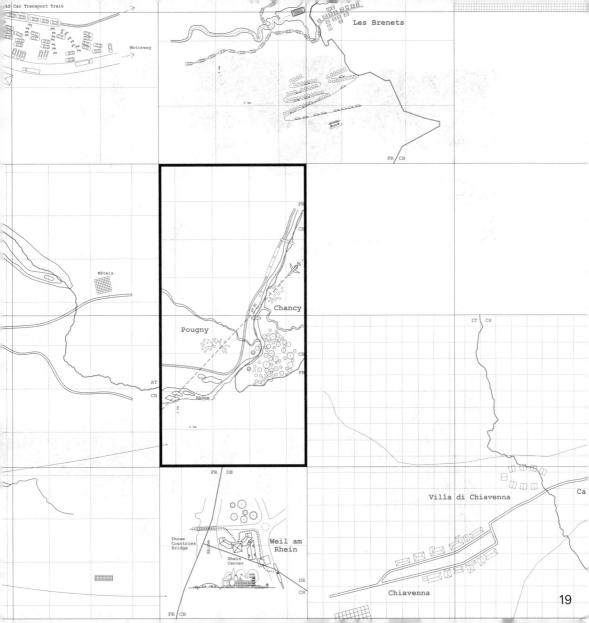

LS Car Transport Train

Motorway

Les Brenets

1 km

FR / CH

MPreis

FR

CH

Chancy

Pougny

CH

FR

AT

CH

Rhône

1 km

FR DE

IT CH

Villa di Chiavenna

Ca

Three
Countries
Bridge

Rhein

Weil am
Rhein

Rhein
Center

DE

CH

Chiavenna

FR CH

19

A couple with a child live on one side of the border, yet work on the far side. On weekdays,................
that serves as the border. *"Vous avez vu le sol qui s'érode de part et d'autre. La frontière passe au...*
C'est de la richesse qui se barre". says R.F. (You've seen how on either side the....
Those chunks of national territories are breaking.

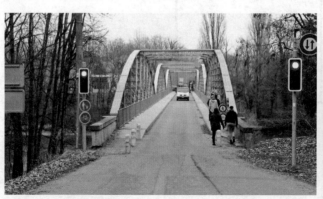 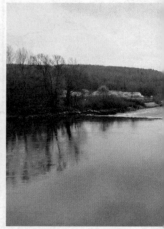

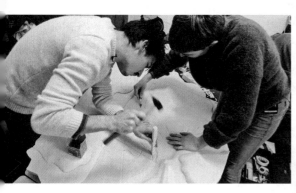

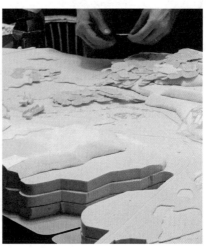

.....they commute by train, car or bicycle. At weekends, they stroll along the banks of the river
............................*milieu du Rhône. Ce sont des bouts de territoires nationaux qui s'en vont, qui fuient.*
soil has been eroded. The boundary runs down the middle of the Rhône.
.......off, escaping. It's wealth that's draining away.)

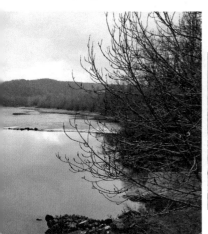

2 Îlet

A group of monks , tunnel workers and a bus driver
Great St. Bernard Pass
CH–IT
45°52′12″N 7°10′19″E
49 km²

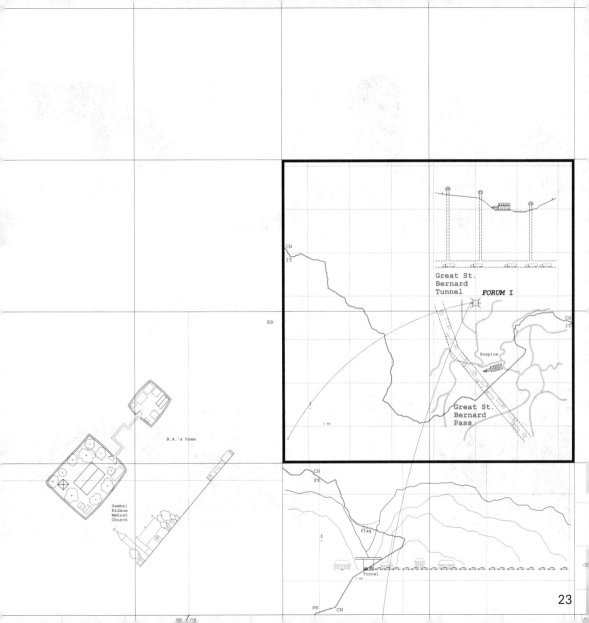

Great St.
Bernard
Tunnel

FORUM I

Great St.
Bernard
Pass

Hospice

CH
IT

CH
IT

CH
IT

ER

R.A.'s home

Sembel
Kidane
Mehret
Church

CH
FR

Flag

Tunnel
1 km

FR CH

1 km

23

The Pass remains open for only four summer months. Heavy snow renders it impassabl
– a small mountain hamlet that straddles the highest point of the pass –...
Tunnel is usable 365 days a year. Annually, some 750,000 vehicles pass through this
A power station was built to serve the tunnel's energy.............

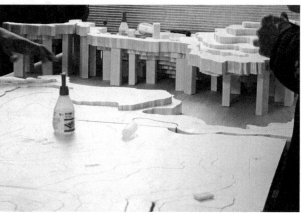

.................for the remainder of the year. A group of monks, the sole inhabitants of the *îlet*
.......................welcome travellers to their hospice. Beneath the pass, the Great St. Bernard
..................privately administered 5.8 kilometres long tunnel, which is subject to a toll.
..needs, as well as for an electric power supply to the hospice.

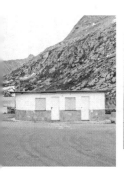

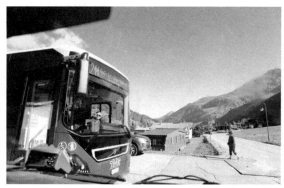

3 Go slow

Transborder Commuters
Col des Roches
CH–FR
47°03′04″N 6°43′12″E
10 km²

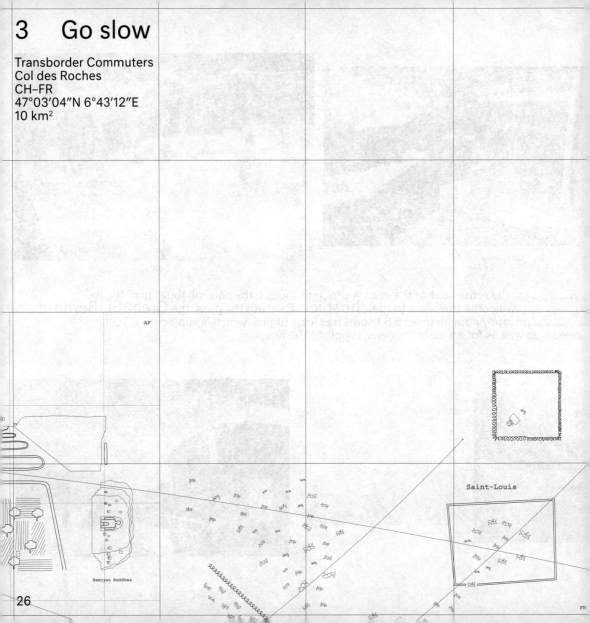

AF

Bamiyan Buddhas

Saint-Louis

FR

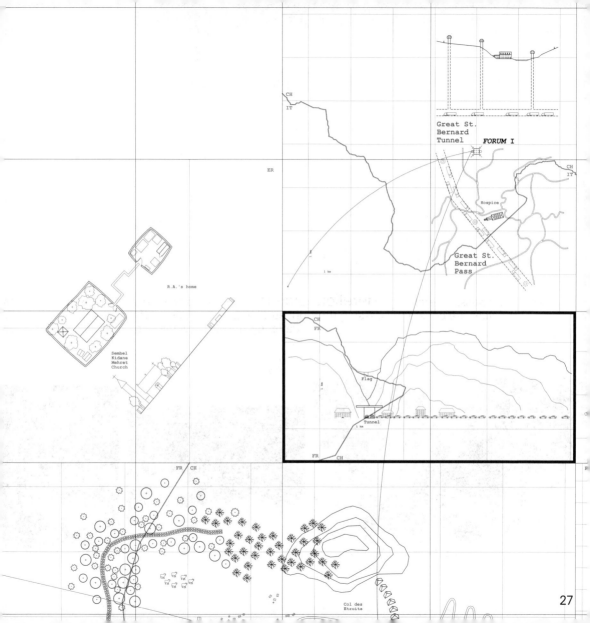

Great St.
Bernard
Tunnel *FORUM* I

CH
IT

CH
IT

ER

Hospice

Great St.
Bernard
Pass

R.A.'s home

Sembel
Kidane
Mehret
Church

CH
FR

Flag

Tunnel

FR CH

FR CH

Col des
Etroits

Down the pass, several large, derelicts buildings testify to now defunct industrial activities. Vehicles are constantly passing through, hurtling into the rocky cliff. The continuous flow....... Patiently, the cars trundle into...

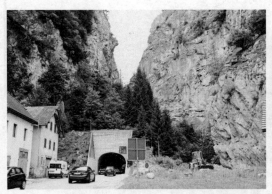
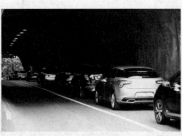

...................The sole access road leads to a tunnel and comes out on the far side of the border.
......of crossborder commuters becomes a go slow – a long, never-ending queue.
.the mountainside, vanishing one after the other.

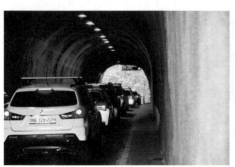

4 Ornitology

Dora Zarzavatzaki
Geneva
CH–FR
46°12′00″N 6°09′00″E
45,6 km²

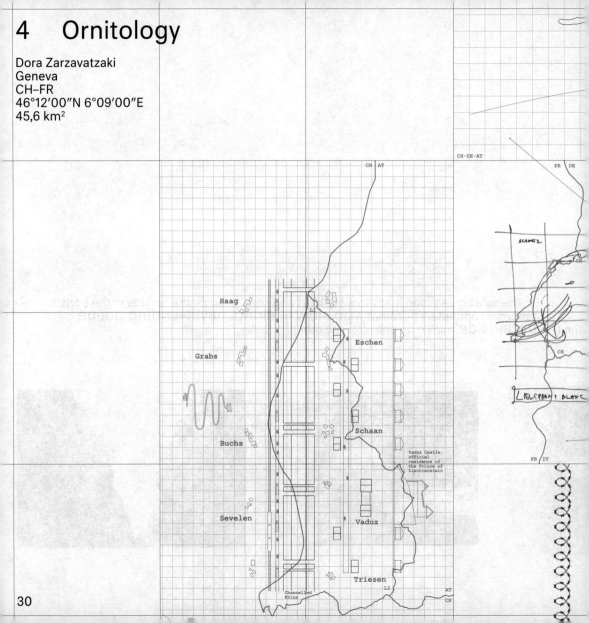

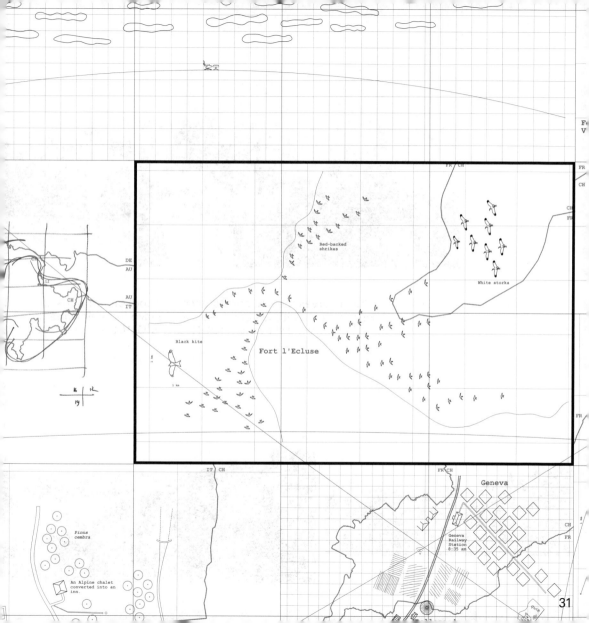

Red-backed
shrikes

White storks

Black kite

Fort l'Ecluse

DE
AU

AU
IT

Pinus
cembra

An Alpine chalet
converted into an
inn.

IT CH

FR CH

FR CH

Geneva

Geneva
Railway
Station
8:35 am

FR CH

FR
CH

CH
FR

FR

CH
FR

31

D.Z. is a wildlife photographer; she observes the sky, constantly on the lookout for birds.................
are due to congregate. Multiple flocks gear up to leave for their winter homes
The birds will skirt the mountain slopes and the....................

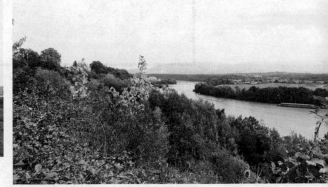

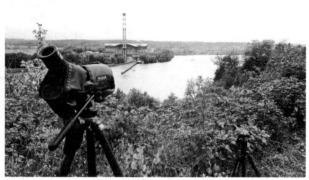

.........Autumn is an animated season on the plain, for hundreds of thousands of migratory birdsBlack kites, red-backed shrikes, white storks will depart for the winter. ..Rhône river in order to find their bearings, and head south.

5 La guerre des vaches

Bénédicte and Vincent Tyrode, Luc Martin
L'Auberson
CH–FR
46°49′05″N 6°27′33″E
63 km²

Saint-Louis

Bundesasylzentrum

Sprachcafé

Novartis Campus

FR
CH

FR CH

Basel

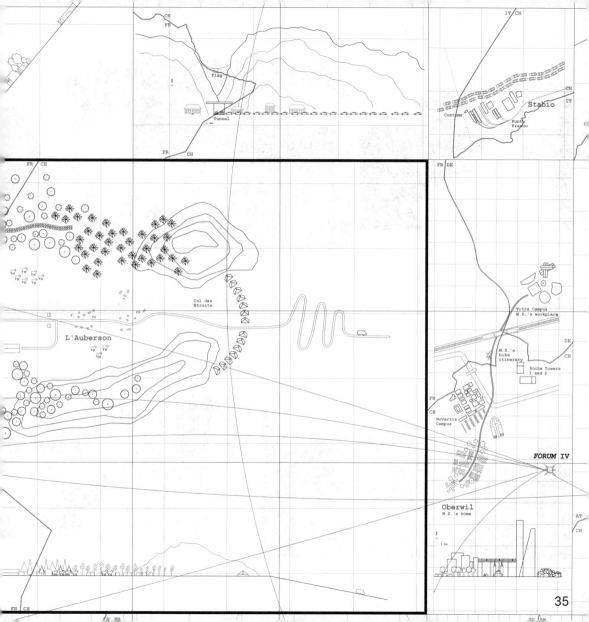

CH
FR

Flag

Tunnel

FR CH

IT/CH

Stabio

Customs

Punto
Franco

CH
IT

C

FR CH

FR DE

FR DE

Col des
Etroits

L'Auberson

Vitra Campus
M.Z.'s workplace

M.Z.'s
bike
itinerary

Roche Towers
1 and 2

DE
CH

FR
CH

Novartis
Campus

FORUM IV

Oberwil
M.Z.'s home

AT
CH

FR CH

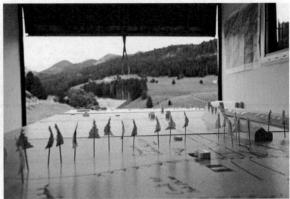

The dairy cows, who graze on the same grass, are raised on an **upland pastures** straddling the crossing over the border and breeding. France and Switzerland have their own **milk** and **cheese**,... within a 20 kilometres radius. Before it can be marketed and reach its ultimate sales outlet,...

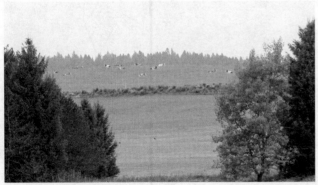

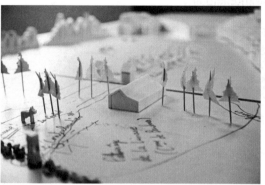

..............Franco-Swiss border. Yet, different labelling standards do not allow those cattle fromas well as their own Protected Designation of Origin (PDO). Cheese thus produced can be soldhowever, it will have to travel 120 kilometres and undergo customs clearance.

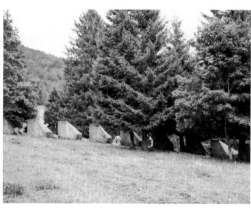
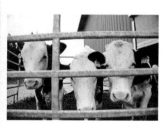

6 Croisière

Tourists in a boat and inhabitants of the municipality
Les Brenets
CH–FR
47°04'10"N 6°42'20"E
20,2 km²

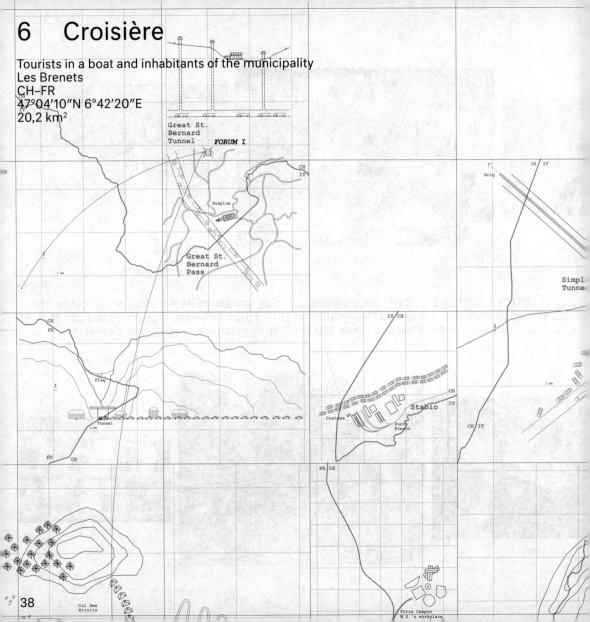

Great St.
Bernard
Tunnel

FORUM I

CH
IT

Hospice

Great St.
Bernard
Pass

Brig

CH IT

Simpl
Tunne

IT CH

FR
CH

Flag

CH
FR

1 km

Custom

Stabio

CH
IT

Tunnel

Punto
Fresco

CH IT

FR
CH

FR DE

Col des
Etroits

Vitra Campus
M.Z.'s workplace

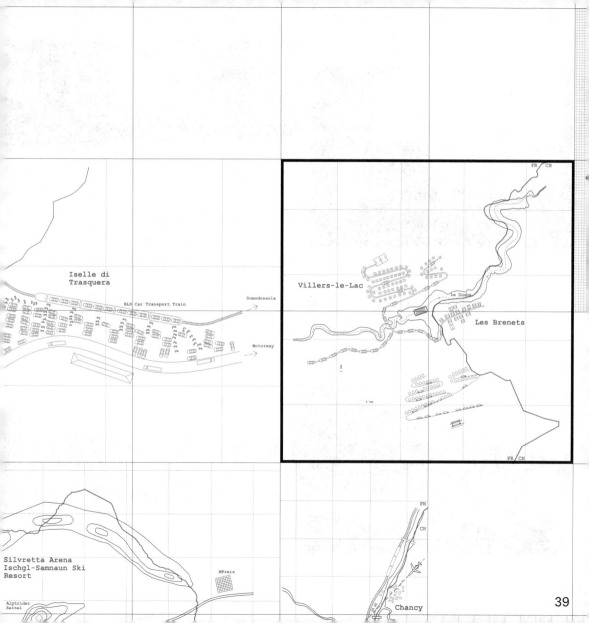

Iselle di
Trasquera

BLS Car Transport Train

Domodossola

Motorway

Villers-le-Lac

Le Doubs

Les Brenets

FR / CH

FR / CH

1 km

Silvretta Arena
Ischgl-Samnaun Ski
Resort

MPreis

Alptrider
Sattel

FR

CH

Chancy

39

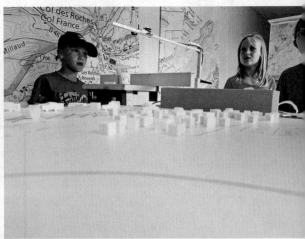

Here, the Franco-Swiss border line follows the course of the Doubs River...................
Overhead, a continuous stream of cars with transborder workers are crossing.....
with identical houses concealed behind impenetrable hedges.....

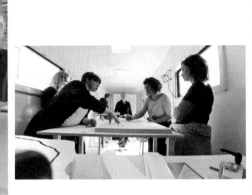
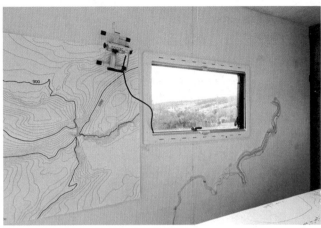

Sitting on a boat, day-trippers on a river cruise are gazing upon the wild ravines.
... a bridge, heading homeward. The road leads to several residential zones
..................................A football pitch lies at the end of the road.

Ursula Fogliada-Salis
Castasegna
CH–IT
46°20'00"N 9°31'00"E
0,5 km²

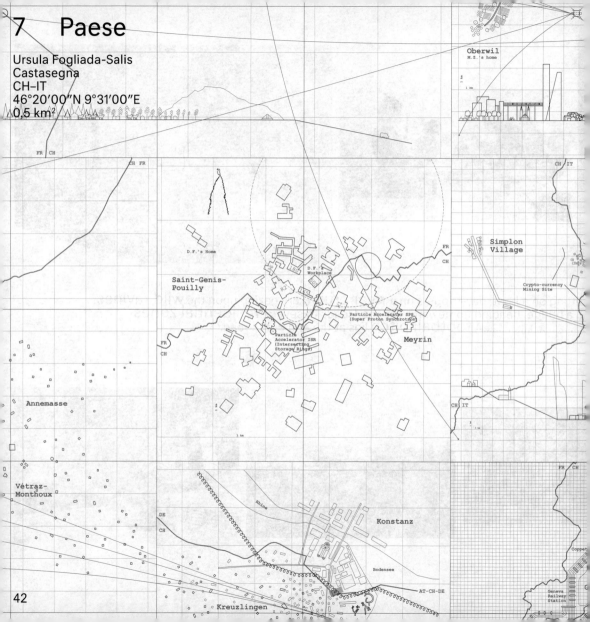

Oberwil
M.Z.'s home
1 km

FR CH
CH FR

CH IT

Simplon
Village

D.F.'s Home

Saint-Genis-
Pouilly

D.F.'s
Workplace

Crypto-currency
Mining Site

FR
CH

FR
CH

Particle Accelerator SPS
(Super Proton Synchrotron)

Particle
Accelerator ISR
(Intersecting
Storage Ring)

Meyrin

Annemasse

CH IT

1 km

1 km

Vétraz-
Monthoux

Rhine

DE
CH

Konstanz

FR CH

Coppet

Bodensee

Geneva
Railway
Station

AT-CH-DE

Kreuzlingen

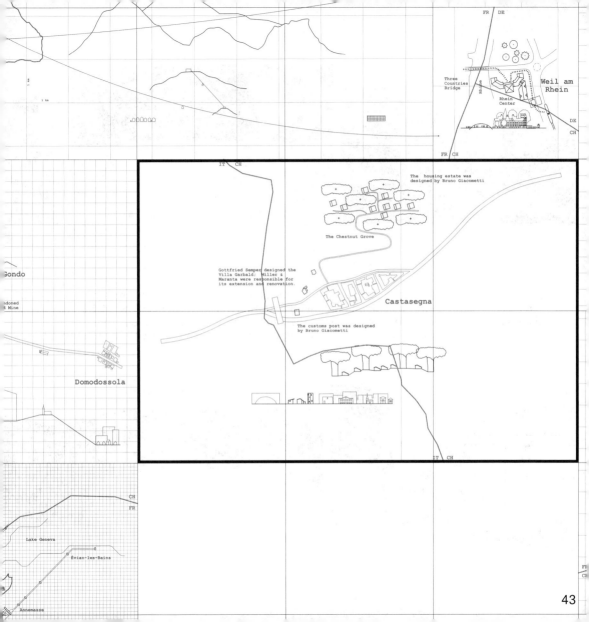

FR DE

Three
Countries
Bridge

Weil am
Rhein

Rhein
Center

DE
CH

FR CH

IT CH

The housing estate was
designed by Bruno Giacometti

The Chestnut Grove

Gondo

Gottfried Semper designed the
Villa Garbald; Miller &
Maranta were responsible for
its extension and renovation.

Abandoned
Gold Mine

Castasegna

The customs post was designed
by Bruno Giacometti

Domodossola

IT CH

CH
FR

Lake Geneva

Évian-les-Bains

FR
CH

Annemasse

Eighteen petrol stations used to operate along the street that runs through the small village...........
will soon close. The roadway has since been paved and the former customs post.........................
controls the continual flow of vehicles crossing the valley. Higher up, a path leads to a
The former customs and the housing estate were designed by Bruno Giacometti...........

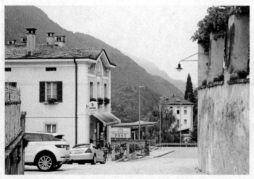

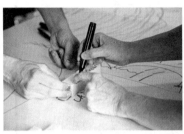
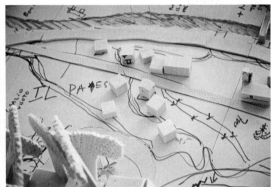

.........of Castasegna. Today, not a single one. All that remains are two businesses and a hotel thatcurrently serves as an exhibition space. The new customs, located below along the bypass,housing estate built for workers at the power station and to a chestnut grove.The village centre features in the inventory of cultural assets of national importance.

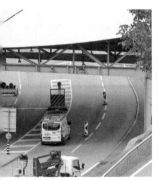

8 Grand Hotel Maloja Palace

Delia Giorgetta
Villa di Chiavenna
CH–IT
46°20′00″N 9°29′00″E
972 km²

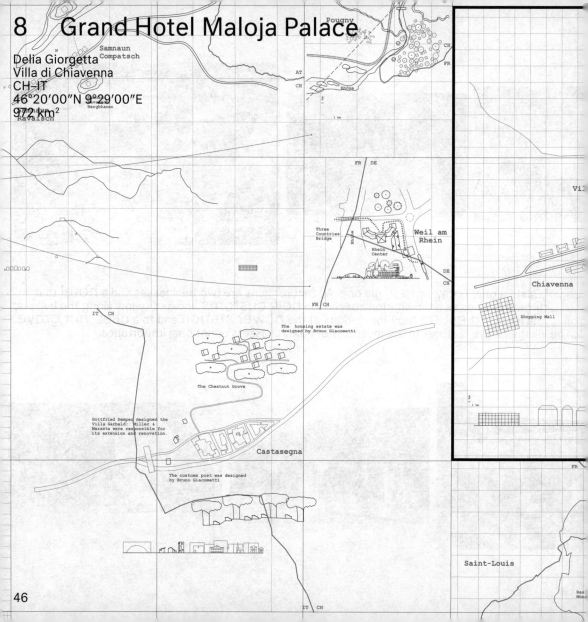

Samnaun
Compatsch

Pougny

AT
CH
Rhône

1 km

FR
CH

FR DE

Three
Countries
Bridge

Rhein

Weil am
Rhein

Rhein
Center

DE
CH

Vi...

Chiavenna

Shopping Mall

IT CH

The housing estate was
designed by Bruno Giacometti

The Chestnut Grove

Gottfried Semper designed the
Villa Garbald; Miller &
Maranta were responsible for
its extension and renovation.

Castasegna

The customs post was designed
by Bruno Giacometti

FR

1 km

Saint-Louis

IT CH

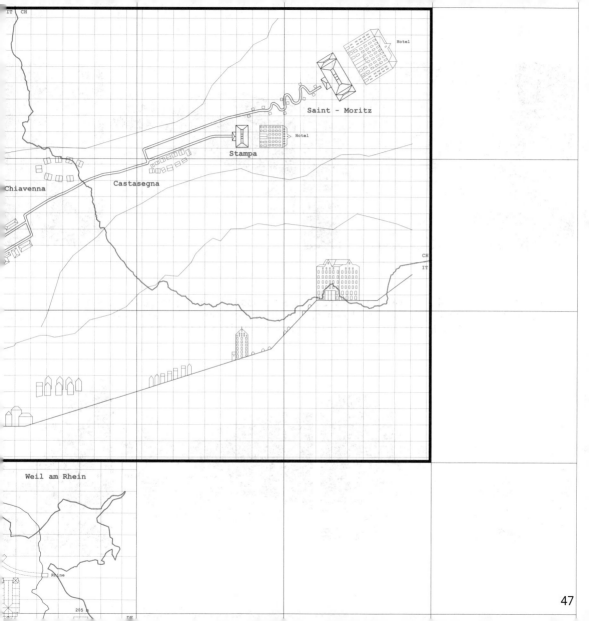

Saint - Moritz

Stampa

Hotel

Chiavenna

Castasegna

Weil am Rhein

47

Every day, a seasonal chambermaid takes a bus across the valley to go to work at two.................
or more hours. Though the nearest town isn't far from her home, she can't find any work there.......
vado solo per lavoro." says D.G. (I usually go into town once a day to do some...............

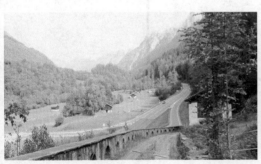
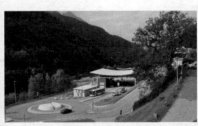

 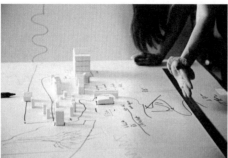

...........luxury hotels in the Maloja Region. Depending on the snow, the commute can take one
.............."*Vado in città quasi una volta al giorno a fare shopping o a trovare gli amici. Dall'altra parte,*
.........shopping or to meet friends. I only go over to the other side when I go to work).

Valentino Del Curto
Lago di Lei
CH–IT
46°28′59″N 9°27′18″E
5,2 km²

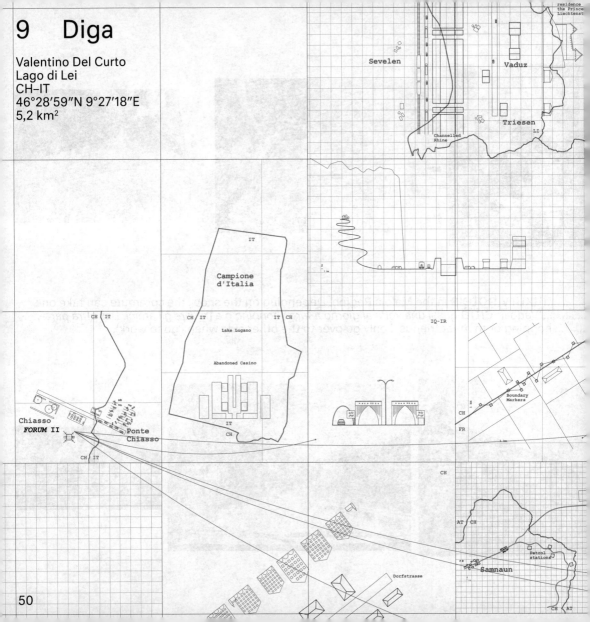

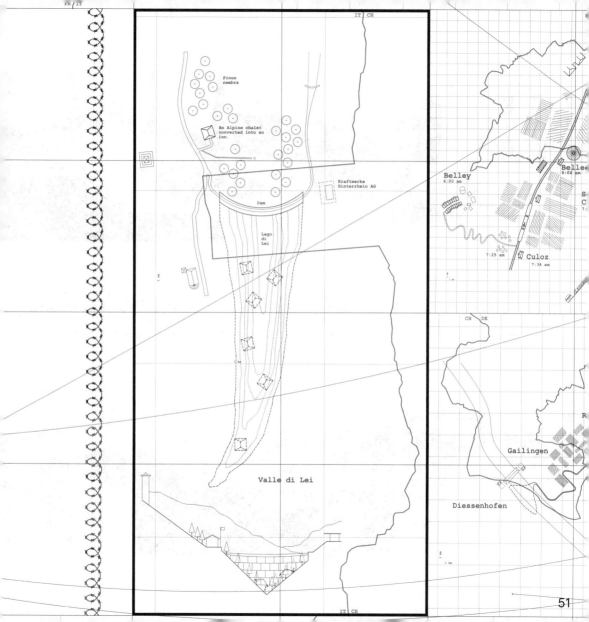

Pinus
cembra

An Alpine chalet
converted into an
inn.

Kraftwerke
Hinterrhein AG

Dam

Lago
di
Lei

Belley
6:00 am

Belle
8:00 am

7:25 am

Culoz
7:34 am

CH DE

Gailingen

Valle di Lei

Diessenhofen

 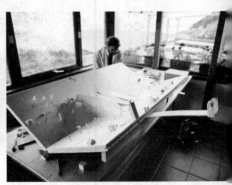

An **Alpine chalet** was converted into an inn up in the mountain pastures. Photos hanging on..........
Swiss pine (*Pinus cembra*) that cover the mountain slopes. To the right, a 690-metre long
1500 men, two cable cars, two roads and a tunnel to erect the dam, which is currently operated.....
but after completion was transferred to Swiss territory following a land swap between both..........

 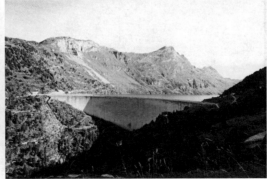 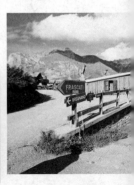

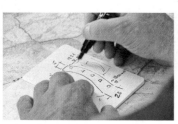

.........its walls retrace the history of the Valle di Lei. Through the window, to the left, are to be seen the
................vaulted reservoir wall buttresses 197 million cubic metres of water. It took five years,
........by Kraftwerke Hinterrhein AG. Its website states: "Originally, the dam stood on Italian territory,
...countries. Almost the entire reservoir, as well as its natural catchment area, is located in Italy."

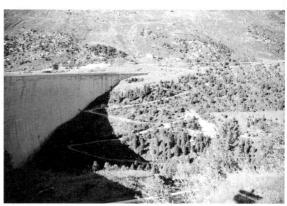

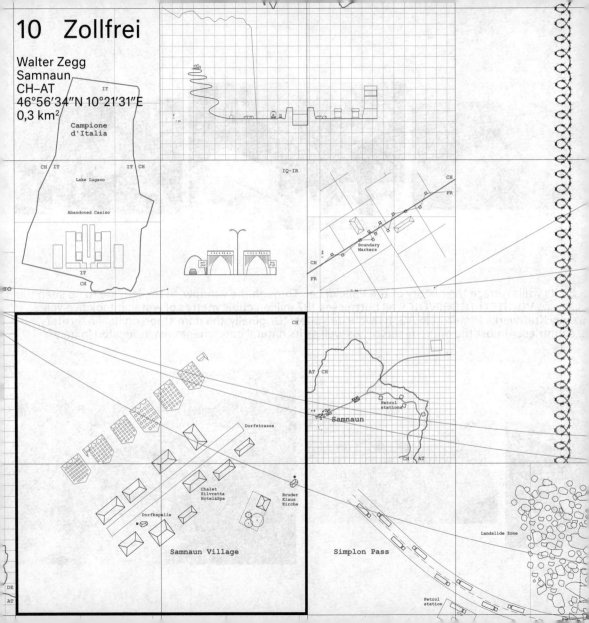

10 Zollfrei

Walter Zegg
Samnaun
CH–AT
46°56'34"N 10°21'31"E
0,3 km²

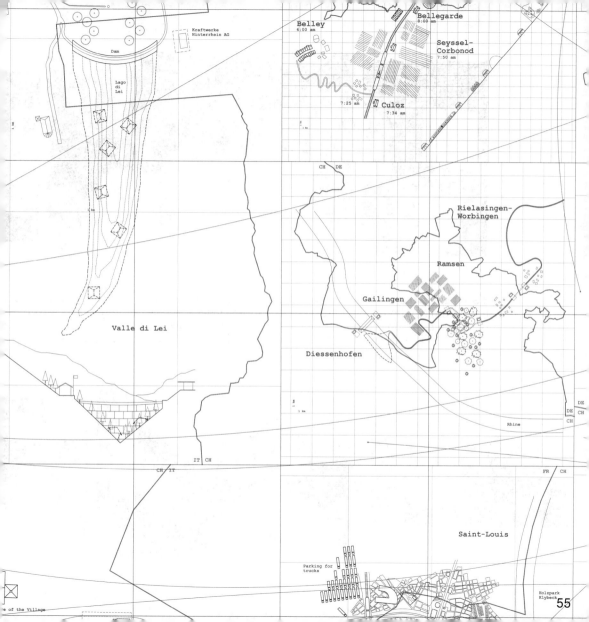

Kraftwerke
Hinterrhein AG

Dam

Lago
di
Lei

Belley
6:00 am

Bellegarde
8:00 am

Seyssel-
Corbonod
7:50 am

7:25 am

Culoz
7:34 am

CH DE

Rielasingen-
Worbingen

Ramsen

Gailingen

Valle di Lei

Diessenhofen

DE DE
CH
CH

Rhine

IT CH

CH IT

FR CH

Saint-Louis

Parking for
trucks

Holzpark
Klybeck

e of the Village

The **village's main street** is lined with luxury hotels, with shops on the.................................
describes the environs in the following terms: "The Alpine village leaves nothing to be desired.......
with superb dining, shopping and outdoor activities. There are over forty................................
who also happens to be an oil trader, belongs to one of the...................

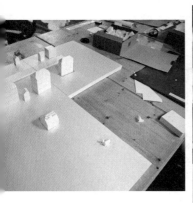

.........ground floor selling duty-free perfumes, jewellery and watches. The tourist office's brochure
.................*Its infrastructure and services are all geared towards a first-class holiday experience filled*
tax-free boutiques, countless well-signed bike paths and hiking trails." The village mayor,
.........handful of families who own all the hotels and shops in the village.

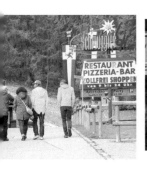

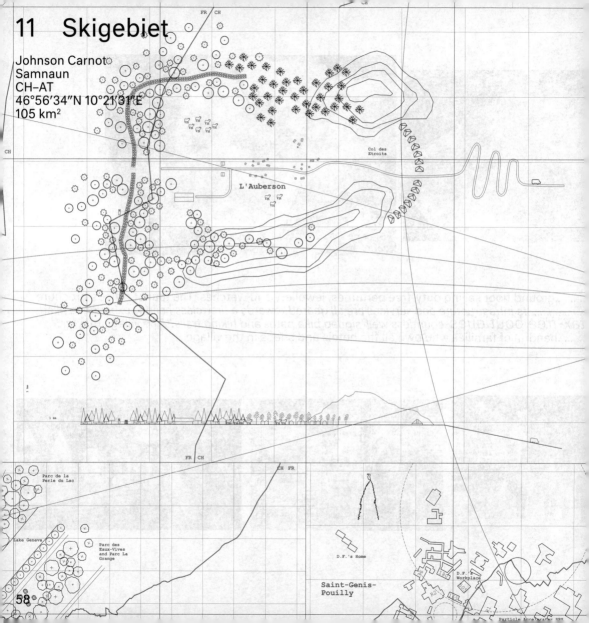

11 Skigebiet

Johnson Carnot
Samnaun
CH–AT
46°56′34″N 10°21′31″E
105 km²

FR CH

CH

Col des
Etroits

L'Auberson

1 km

FR CH

CH FR

Parc de la
Perle du Lac

Lake Geneva

Parc des
Eaux-Vives
and Parc La
Grange

D.F.'s Home

D.F.
Workplace

Saint-Genis-
Pouilly

Particle Accelerator SPS

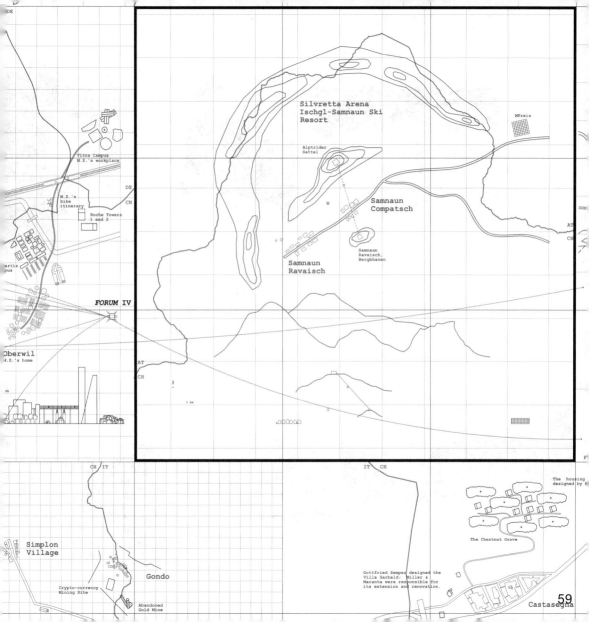

DE

Vitra Campus
M.Z.'s workplace

M.Z.'s
bike
itinerary

Roche Towers
1 and 2

DE
CH

*artis
*ous

FORUM IV

Oberwil
M.Z.'s home

AT
CH

km

1 km

Silvretta Arena
Ischgl-Samnaun Ski
Resort

MPreis

Alptrider
Sattel

Samnaun
Compatsch

Samnaun
Ravaisch,
Bergbhanen

Samnaun
Ravaisch

F

CH IT

IT CH

The housing
designed by B

Simplon
Village

Gondo

Crypto-currency
Mining Site

Abandoned
Gold Mine

The Chestnut Grove

Gottfried Semper designed the
Villa Garbald; Miller &
Maranta were responsible for
its extension and renovation.

Above the village, the upscale Silvretta Arena Ischgl-Samnaun ski resort straddles.........................
resort and responsible for the skiing area, is also in charge of keeping the slopes in good shape.....
"Das ist die Welt in Ordnung." (Here, the world is orderly). During early 2020, Ischgl was one of.
contracted the virus there, before..........................

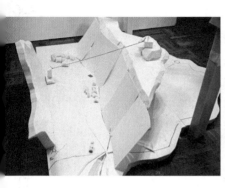

.......the Swiss and Austrian border. It has also been dubbed as "Ibiza on Ice." J.C., co-founder of the
.........Each day, he looks all around the place, all while inspecting and shaping his domain. For him,
....................Europe's major hotspots for Covid-19 infections. Tourists in their tens of thousands
......subsequently spreading it across the planet.

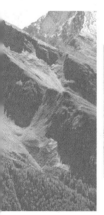

12 Exclave

Manuela Leitsberger
Samnaun
CH–AT
46°56'34"N 10°21'31"E
784 km²

Campione
d'Italia

CH IT IT CH

Lake Lugano

Abandoned Casino

IT

CH

IQ-IR

CH

FR

Boundary
Markers

CH

FR

CH

AT CH

Samnaun

Petrol
stations

CH AT

Dorfstrasse

Chalet
Silvretta
Hotel&Spa

Bruder
Klaus
Kirche

Dorfkapelle

Samnaun Village

Simplon Pass

Landslide Zone

Petrol
station

DE
AT

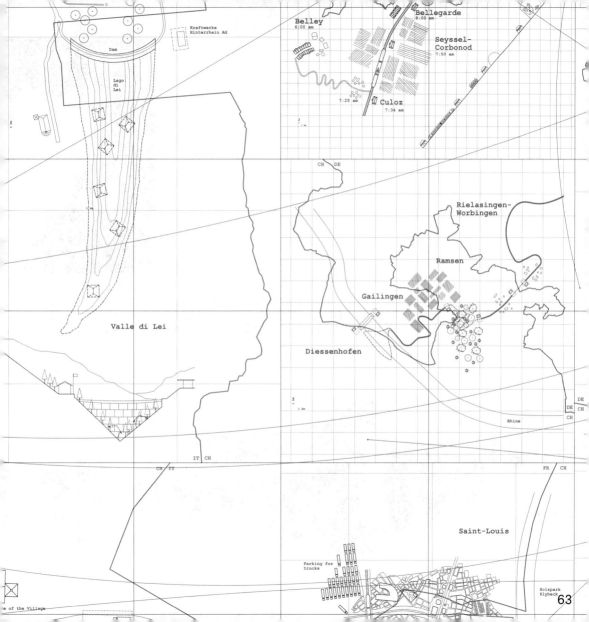

Kraftwerke
Hinterrhein AG

Dam

Lago
di
Lei

Belley
6:00 am

Bellegarde
8:00 am

Seyssel-
Corbonod
7:50 am

7:25 am

Culoz
7:34 am

CH DE

Rielasingen-
Worbingen

Ramsen

Gailingen

Valle di Lei

Diessenhofen

DE DE
 CH

CH
Rhine

IT CH

CH IT

FR CH

Saint-Louis

Parking for
trucks

Holzpark
Klybeck

of the Village

63

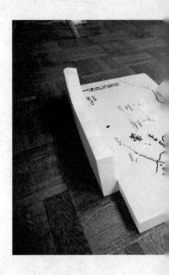

The sole access to the "exclave" used to be via a road on the Austrian side of the border..... since been built on the far side of the ravine in order to reach the same location,................ entrance to the village. Given their tax-free status, these two.....

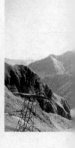

..................It runs halfway up the cliffside. Another more winding and less comfortable road has ..though one hasn't to exit Switzerland. Sugar and petrol are still sold at the petrol stations at the primary products are cheaper here than elsewhere.

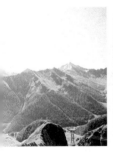
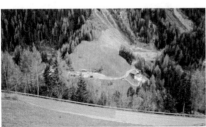
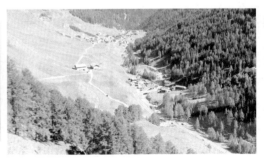

13 Bellevue

Maurizio Usan, Sebastian Squaratti
Gondo
CH–IT
46°11′45″N 8°08′26″E
0,2 km²

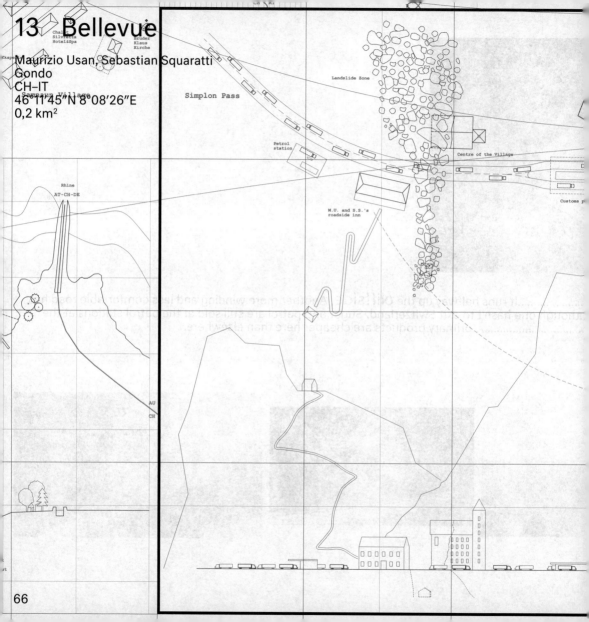

Simplon Pass

Landslide Zone

Petrol station

Centre of the Village

Customs p

M.U. and S.S.'s roadside inn

Rhine
AT–CH–DE

AU

CH

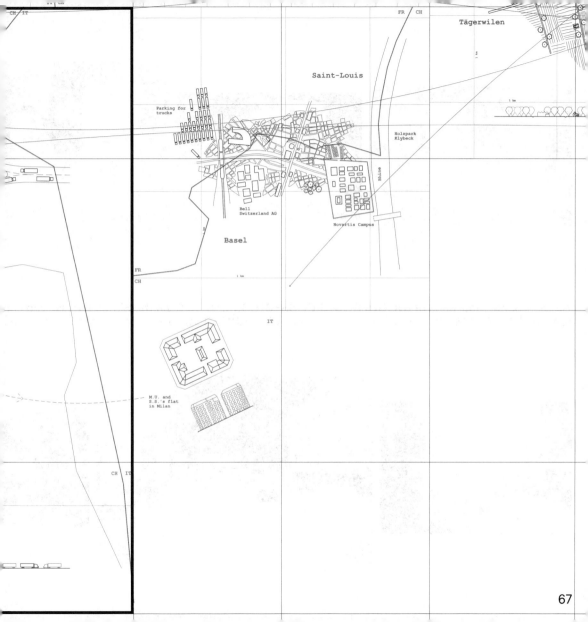

All year round, thousands of juggernauts criss-cross Europe via the Simplon Pass. One can
road in the centre of the village of Gondo, new buildings have been erected in the wake..

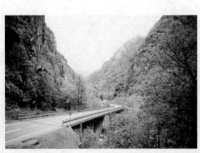
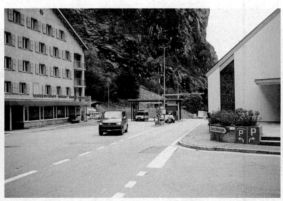

..........see various brands of crisps, cosmetics and drinks advertised on their tarps. After a bend in the
.....of a **recent disaster**. In 2000, a landslide washed half the village away, killing fourteen people.

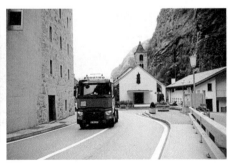
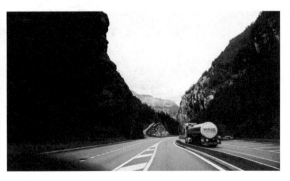

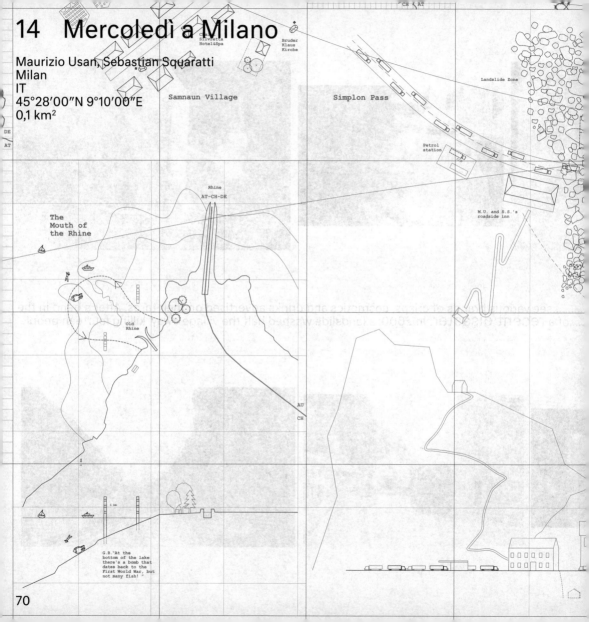

14 Mercoledì a Milano

Maurizio Usan, Sebastian Squaratti
Milan
IT
45°28'00"N 9°10'00"E
0,1 km²

Silvretta
Hotel&Spa

Bruder
Klaus
Kirche

Samnaun Village

Simplon Pass

Landslide Zone

Rhine
AT-CH-DE

The
Mouth
of
the Rhine

Petrol
station

M.U. and S.S.'s
roadside inn

Old
Rhine

AU
CH

1 km

G.B. "At the
bottom of the lake
there's a bomb that
dates back to the
First World War, but
not many fish!"

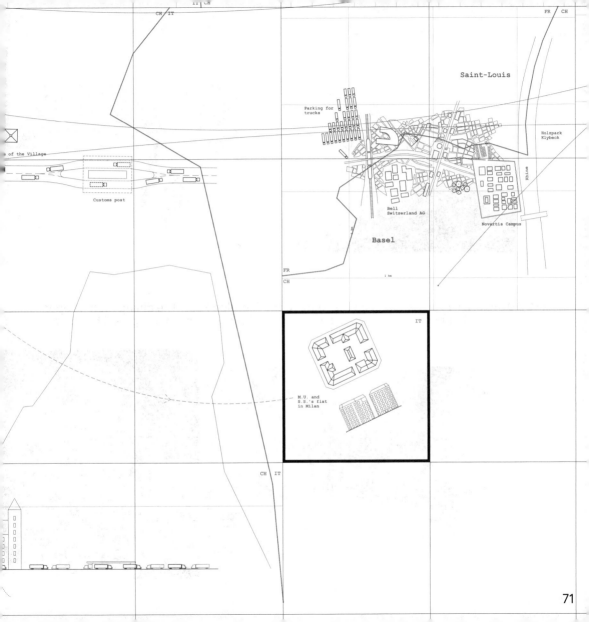

IT CH

FR CH

Saint-Louis

Parking for
trucks

Holzpark
Klybeck

of the Village

Rhine

Customs post

Bell
Swizerland AG

Novartis Campus

Basel

FR

CH

1 km

IT

M.U. and
S.S.'s flat
in Milan

CH IT

A **roadside inn** can be found on the route to the Simplon Pass. The dining room is open............
first floor. Downstairs is the accommodation for the innkeepers. They go to...............

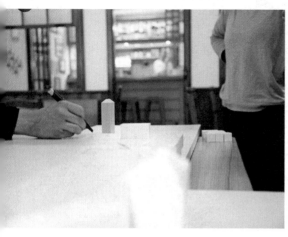

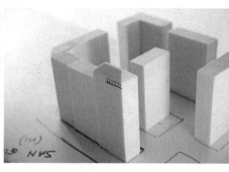

..............on three sides. Around the bar, guests converse in a local dialect. Guest rooms are on the
.........their apartment in Milan every Wednesday, as the inn closes for the day.

15 Crypto-Currency Mining Farm

Rolf Gruber
Gondo
CH–IT
46°11'45"N 8°08'26"E
784 km²

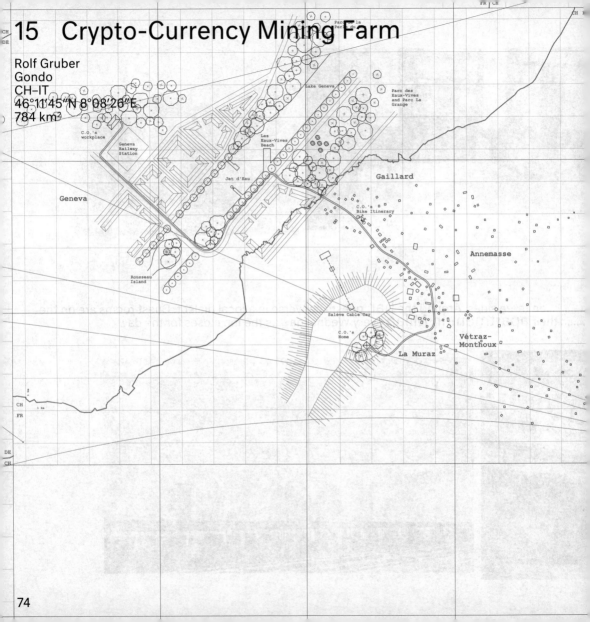

C.O.'s
workplace

Geneva
Railway
Station

Les
Eaux-Vives
Beach

Lake Geneva

Parc La
Perle du

Parc des
Eaux-Vives
and Parc La
Grange

Gaillard

Geneva

Jet d'Eau

C.O.'s
Bike Itinerary

Annemasse

Rousseau
Island

Salève Cable Car

C.O.'s
Home

Vétraz-
Monthoux

La Muraz

CH
FR

DE
CH

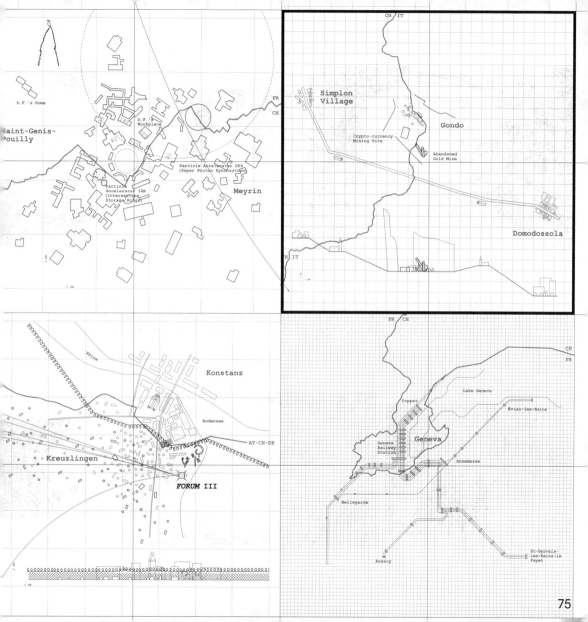

Saint-Genis-Pouilly

D.F.'s Home

D.F.'s Workplace

Particle Accelerator SPS
(Super Proton Synchrotron)

Particle
Accelerator ISR
(Intersecting
Storage Rings)

Meyrin

FR
CH

Simplon
Village

Gondo

Crypto-currency
Mining Site

Abandoned
Gold Mine

Domodossola

CH IT

CH IT

1 km

Rhine

Konstanz

Bodensee

AT-CH-DE

Kreuzlingen

FORUM III

1 km

FR CH

CH
FR

Lake Geneva

Coppet

Évian-les-Bains

Geneva

Geneva
Railway
Station

Annemasse

Bellegarde

Annecy

St-Gervais-
les-Bains-le
Fayet

75

One has to cross a **stream** and pass through a **wood** in order to reach an.........................
Below the cliffs of dark, black rock is a **mundane hanger**. Inside, a "crypto-currency...
to produce bitcoins is in operation. Other similar start-ups are also setting up in the **village**.......

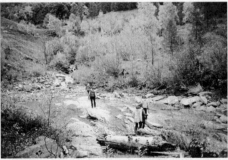

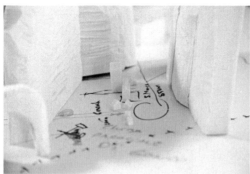
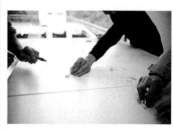

abandoned gold mine. Nowadays, it has become somewhat of a tourist attraction.
......mining farm" where hundreds of extremely fast computer processors run continuously
These fledgling companies consume lots of power, but electricity is attractively priced in Gondo.

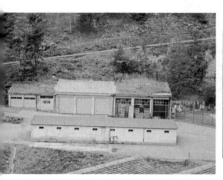

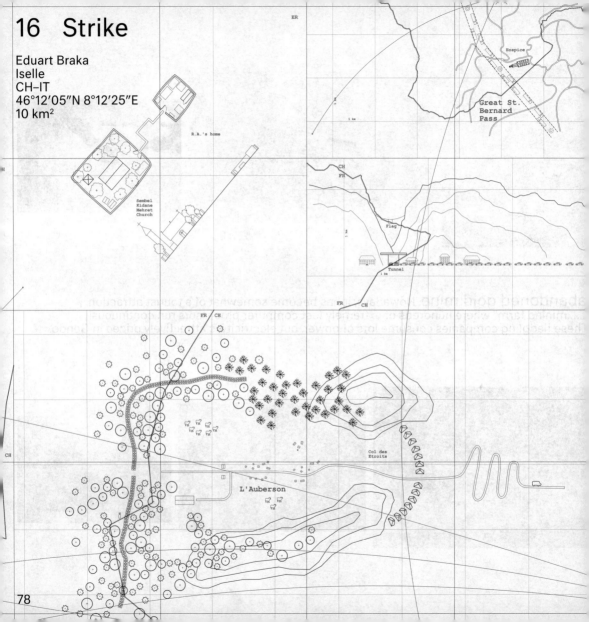

16 Strike

Eduart Braka
Iselle
CH–IT
46°12′05″N 8°12′25″E
10 km²

R.A.'s home

Sembel
Kidane
Mehret
Church

ER

Hospice

Great St.
Bernard
Pass

CH
FR

Flag

Tunnel
1 km

1 km

FR CH

FR CH

CH

Col des
Etroits

L'Auberson

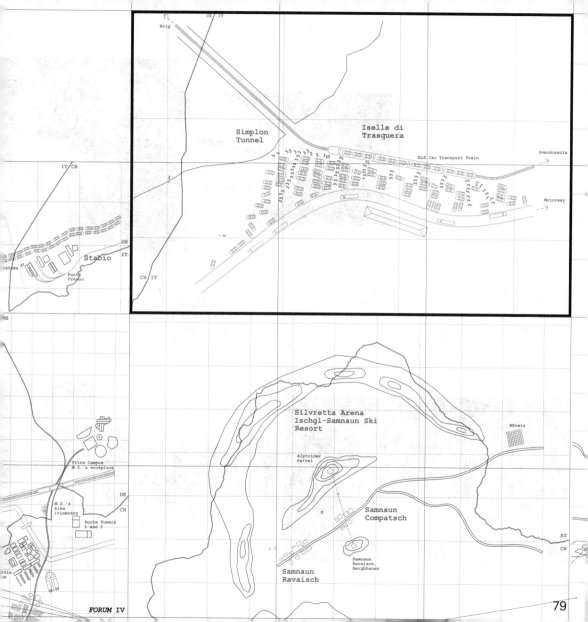

Brig

CH IT

Simplon
Tunnel

Iselle di
Trasquera

BLS Car Transport Train

Domodossola

Motorway

IT/CH

1 km

CH

IT

Stabio

Punto
Franco

CH IT

Silvretta Arena
Ischgl-Samnaun Ski
Resort

MPreis

Alptrider
Sattel

Vitra Campus
M.Z.'s workplace

DE

CH

Samnaun
Compatsch

M.Z.'s
bike
itinerary

Roche Towers
1 and 2

Samnaun
Ravaisch,
Bergbahnen

AT

CH

Samnaun
Ravaisch

It takes some seventeen minutes to pass through the Simplon tunnel by **train**. On arriving over on....
of the station in any available free space. A **car transport train** enters the station.....................
An uninterrupted flow of passengers alights. Some take the bus. The other *"operai"* (worke
Within several minutes, the station and its environs become deserted. E.B. is a trade unionist........
between those train carriages reserved for tourists (operated by SBB)..................

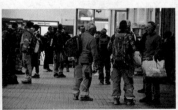

...the Italian side, the platforms in the station at the village of Iselle are empty. Cars are parked in front
The cars drive off the train and quickly veer toward the road. A passenger train pulls in just behind.
.................hurriedly get into their **cars, illegally parked**, in the direction of the motorway.
.He initiated a strike to protest against the qualitative disparity (punctuality, comfort and quantity)
..........................and those consigned for crossborder workers (operated by BLS).

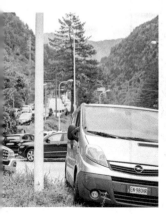

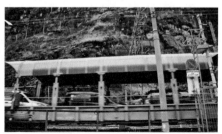

17 Filo spinato

Francesco Garufi
Domodossola
IT
46°06'00"N 8°18'00"E
–

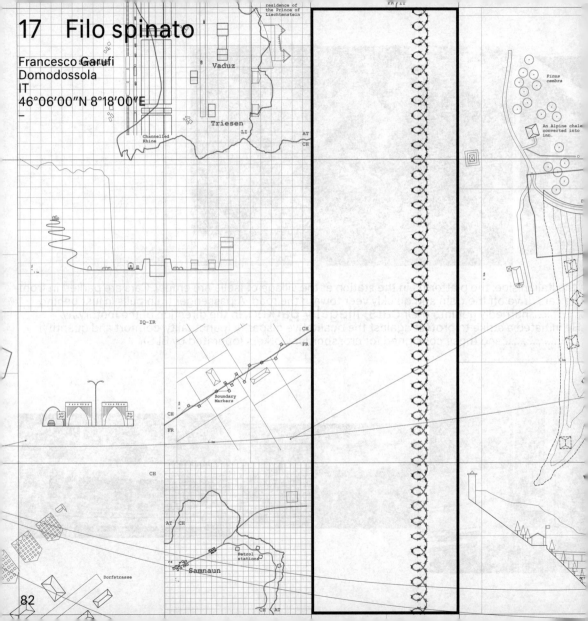

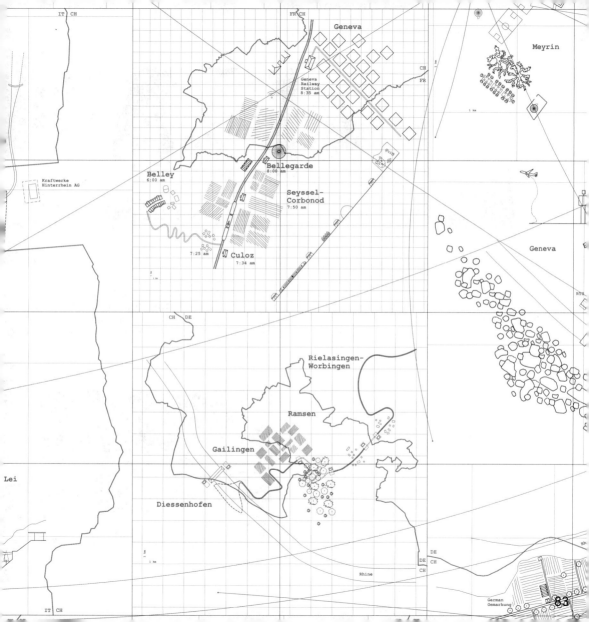

F.G., a doctor at the hospital, relates an episode he experienced in the emergency department........
family to Italy. In a room at the railway station in Brig, the seven-month pregnant woman...............
In pain, she asked for assistance. The border guards refused to call for help. Upon arrival in.......
"Per la maggior parte del mondo, il confine è un filo spinato"

...several years ago: "Border guards were responsible for implementing the deportation of a Syrian and her husband were waiting for a long time for the train meant to carry them across the border. .Domodossola, the woman was taken to the emergency room. Sara died in *utero*." F.G. states:(For most people in the world, the border is barbed wire).

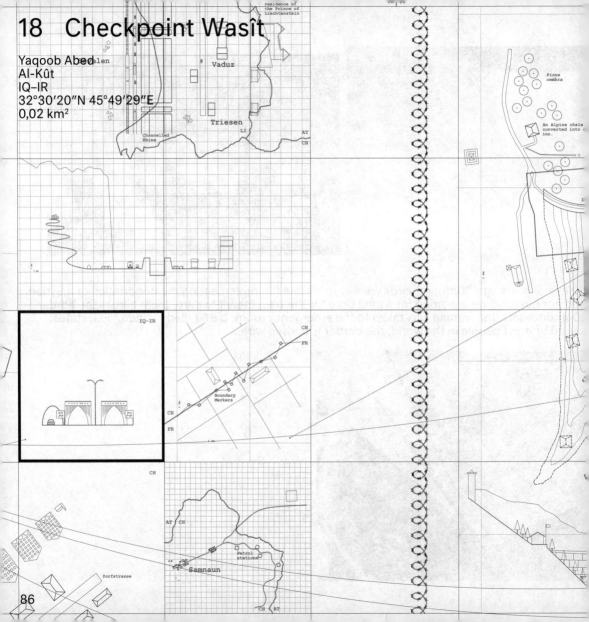

18 Checkpoint Wasît

Yaqoob Abed
Al-Kût
IQ–IR
32°30′20″N 45°49′29″E
0,02 km²

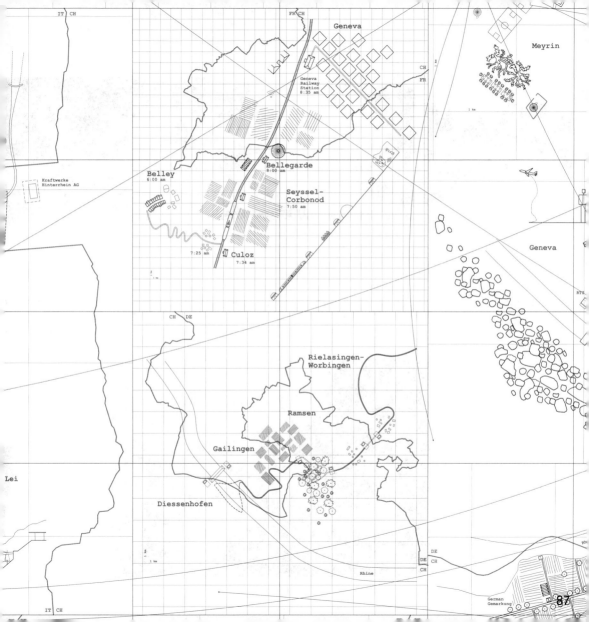

Meyrin

Geneva

FR CH

Geneva

Geneva
Railway
Station
8:35 am

CH
FR

Belley
6:00 am

Bellegarde
8:00 am

Kraftwerke
Hinterrhein AG

Seyssel-
Corbonod
7:50 am

7:25 am

Culoz
7:34 am

1 km

CH DE

Rielasingen-
Worbingen

RTS

Ramsen

Gailingen

Lei

Diessenhofen

DE
CH

DE
CH

Rhine

German
Gemarkung

87

IT CH

Checkpoint Wasît is situated on the road leading from Baghdad to the Iranian border, not far from the
In Iraq, such checkpoints are owned by private security companies.................................
He invited us along to visit the rampart walls of the Bellinzona...........

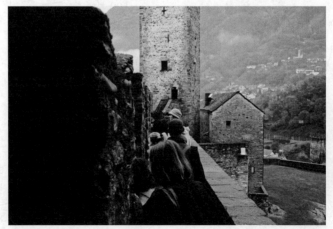

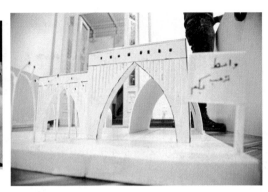

.........city of Al-Kût. Underneath a large archway, cars stop, entry and exit movements monitored.
...Before arriving in Europe, Y.A. used to work as a security guard at Checkpoint Wasît.
........................Castelgrande, an ancient fortified internal border.

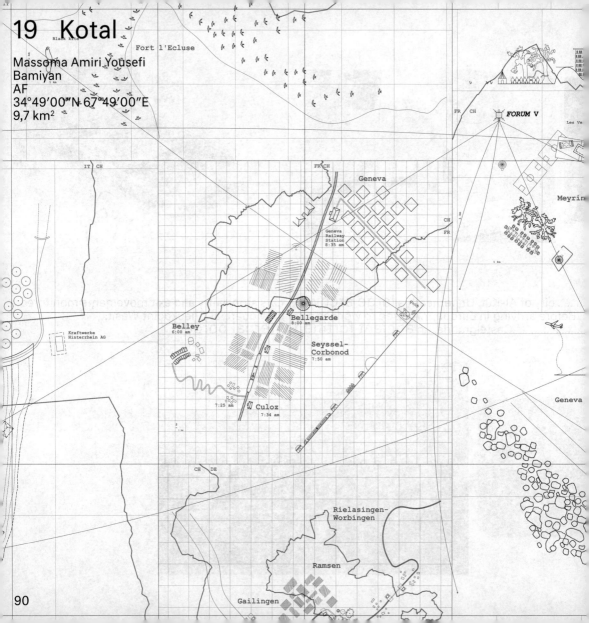

19 Kotal

Massoma Amiri Yousefi
Bamiyan
AF
34°49'00"N 67°49'00"E
9,7 km²

Black Area

Fort l'Ecluse

FORUM V

Les Va

Meyrin

IT CH

FR CH

Geneva

Geneva
Railway
Station
8:35 am

CH

FR

Belley
6:00 am

Bellegarde
8:00 am

Kraftwerke
Hinterrhein AG

Seyssel-
Corbonod
7:50 am

Geneva

7:25 am

Culoz
7:34 am

CH DE

Rielasingen-
Worbingen

Ramsen

Gailingen

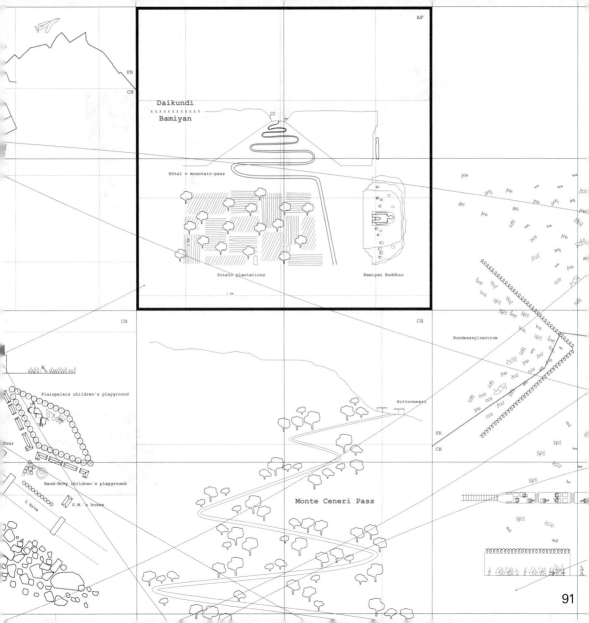

AF

Daikundi
x x x x x x x x x x x x
Bamiyan

Kôtal = mountain-pass

Potato plantations

Bamiyan Buddhas

1 km

FR
CH

CH

CH

Bundesasylzentrum

Plainpalais children's playground

Sottoceneri

FR
CH

Baud-Bovy children's playground

Monte Ceneri Pass

G.M.'s house

L'Arve

M.A.Y. is a lawyer. Before coming to Europe, she grew up in Afghanistan and worked in Iran....
beneath the Monte Ceneri Pass. The Bamiyan Valley serves as an access to the neighbouring.......
of the destruction wrought by the Taliban on the monumental Buddha statues

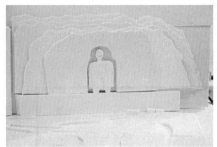
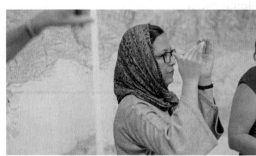

...............She is still waiting for an answer to her asylum application. She lives in Switzerland, Daykundi province. Formerly frequented by tourists, Bamiyan has attained notoriety on accountthere in 2001. Nowadays, local farmers live mainly from the potato harvest.

20 Monte

Teimoor Shah Yousefi
Monteceneri
CH
46°06′13″N 8°56′02″E
1,1 km²

Kötal = mountain-pass

Potato plantations

Bamiyan Buddhas

1 km

Bundesasylzentrum

Sottoceneri

FR
CH

Plainpalais children's playground

RTS_Tour

Baud-Bovy children's playground

L'Arve

G.M.'s house

Monte Ceneri Pass

Rhine

Paradies

Sopraceneri

CH / DE

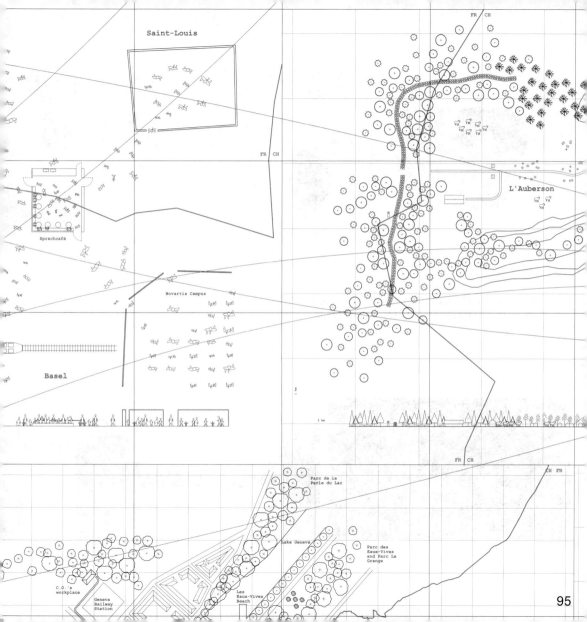

Saint-Louis

FR CH

L'Auberson

Sprachcafé

Novartis Campus

Basel

FR CH

CH FR

Parc de la
Perle du Lac

Lake Geneva

Parc des
Eaux-Vives
and Parc La
Grange

C.O.'s
workplace

Geneva
Railway
Station

Les
Eaux-Vives
Beach

T.S.Y. is a doctor. Before coming to Europe, he lived in Afghanistan and worked in Iran.....................
Monte Ceneri Pass. This Alpine pass is one of Switzerland's numerous internal borders....
The route through this Alpine............

......He is still waiting to an answer for his asylum application. He lives in Switzerland, beneath the
...................It delineates two regions: the Sopraceneri in the north and the Sottoceneri in the south.
...pass is twenty-nine kilometres long.

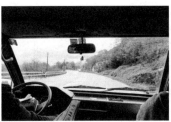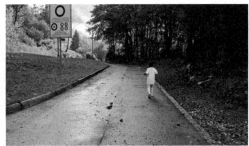

21 Kidane Mehret Church

Ruta Asmelash
Asmara
ER
15°20'00"N 38°56'00"E
0,5 km²

Daikundi
xxxxxxxxxxxx
Bamiyan

Kōtal = mountain-pass

Potato-plantations

Bamiyan Buddhas

1 km

CH
IT

ER

R.A.'s home

CH

Sembel
Kidane
Mehret
Church

FR CH

Saint-Louis

FR CH

99

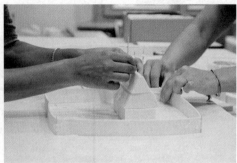

R.A. arrived in Europe via Libya and the Mediterranean. She used to be a military...............
between her **home** and the **church** was uncultivatable and how the walls of the......................
Now, the land between her home and the river is mostly planted with trees.....

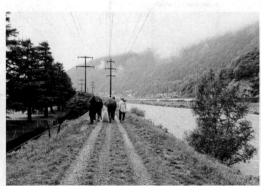

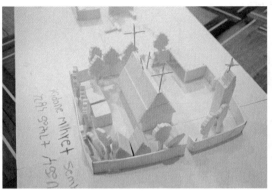

secretary in Eritrea. She grew up in Sembel, a suburb of Asmara. She recalls how the land
......buildings were made of stone. She currently lives in Switzerland, close to the Ticino river.
..The buildings are made of grey concrete.

22 CFA

Chiara Orelli, Valeria Canova, Laura Melera
Chiasso
CH–IT
45°50′05″N 9°01′55″E
0.3 km²

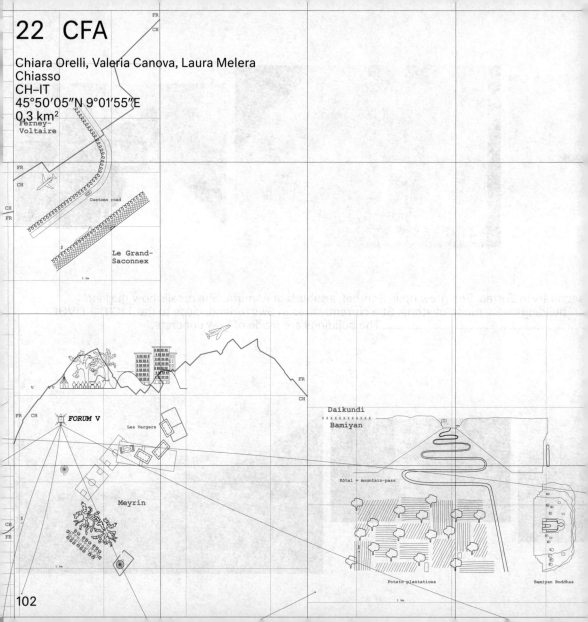

Ferney-
Voltaire

FR
CH

FR
CH

CH
FR

Customs road

Le Grand-
Saconnex

1 km

FORUM V

Les Vergers

FR CH

FR
CH

CH
FR

Meyrin

1 km

Daikundi
x x x x x x x x x x x
Bamiyan

Kôtal = mountain-pass

Potato plantations

Bamiyan Buddhas

1 km

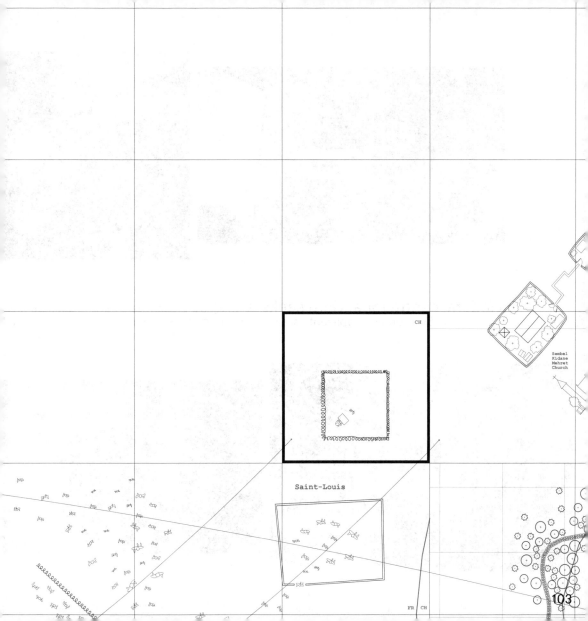

CH

Sembel
Kidane
Mehret
Church

Saint-Louis

FR CH

103

A **federal centre for asylum seekers** (CFA) is a place where asylum seekers file..
In Switzerland, applicants are placed in one of the twenty or so CFAs across the
Most CFAs...

..their application and where those involved in the procedure examine those applications.
...nation for the duration of the procedure (140 days for a fast-track procedure).
.........are located near the border.

23 Condominium

Pascal Müller
Lake Constance
CH–AT–DE
47°39′00″N 9°19′00″E
536 km²

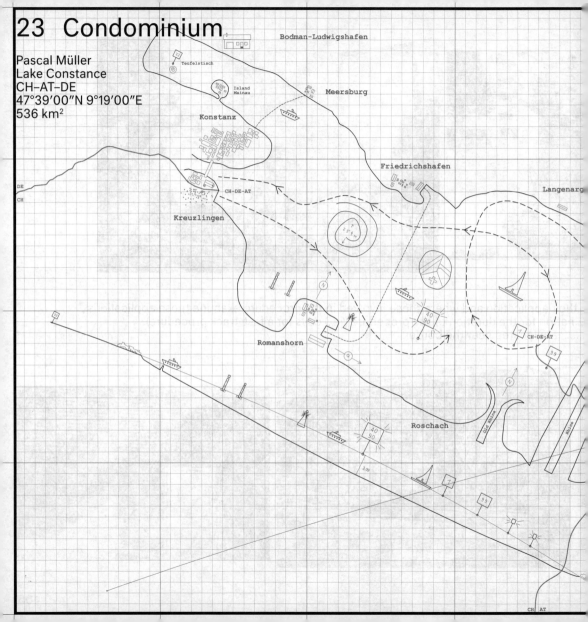

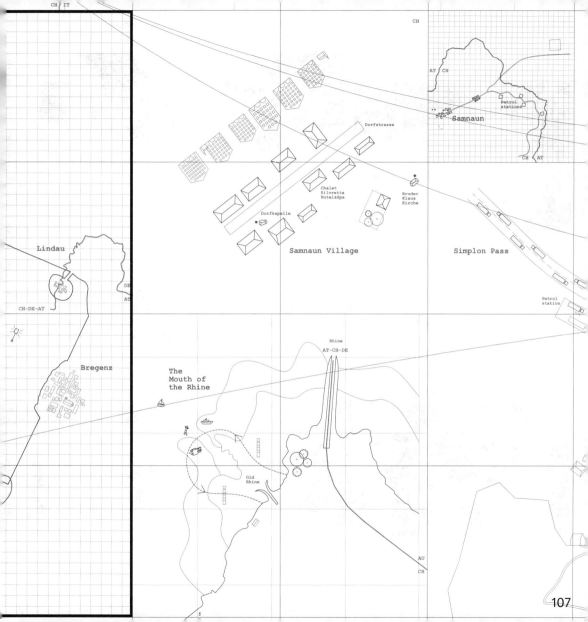

CH / IT

CH

AT CH

Patrol
stations

Samnaun

CH AT

Dorfstrasse

Chalet
Silvretta
Hotel&Spa

Bruder
Klaus
Kirche

Dorfkapelle

Samnaun Village

Simplon Pass

Lindau

Petrol
station

CH-DE-AT

DE

AT

Rhine
AT-CH-DE

Bregenz

The
Mouth of
the Rhine

Old
Rhine

AU

CH

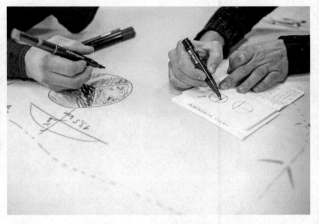

P.M. is a sailor. He works on the **ferry** that crosses Lake Constance. For him, "the Lake doesn
Germany. The boundary line doesn't appear on any official maps of the three countries. In the case of.
the lake is a "condominium," in other words, as formulated in international public law, "a territory......
Germany has not formulated...........

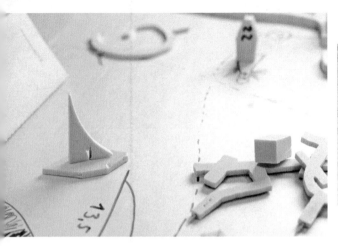

........have a state border." In fact, the lake constitutes the border between Switzerland, Austria, and
..............................Switzerland, the border should pass right through the middle of the lake. For Austria,
.............over which several sovereign states exercise joint sovereignty by dint of mutual agreement."
....any official position on the issue.

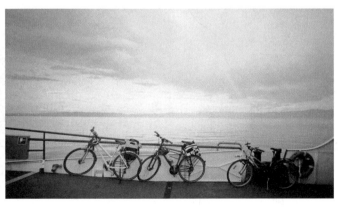

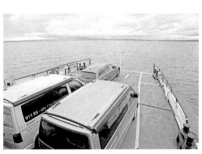

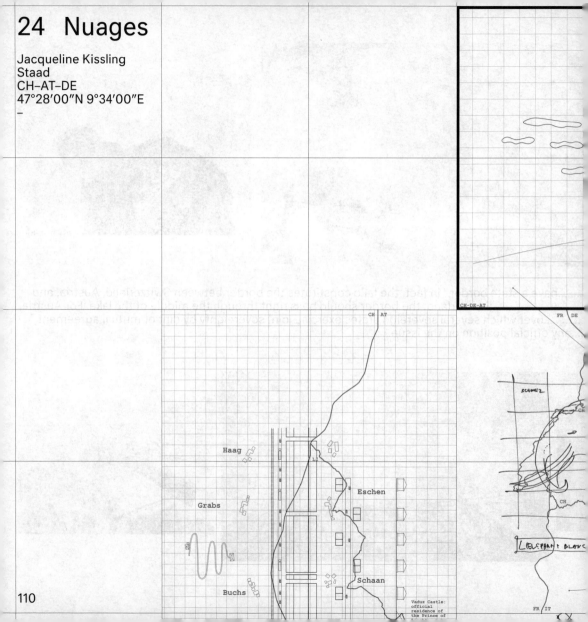

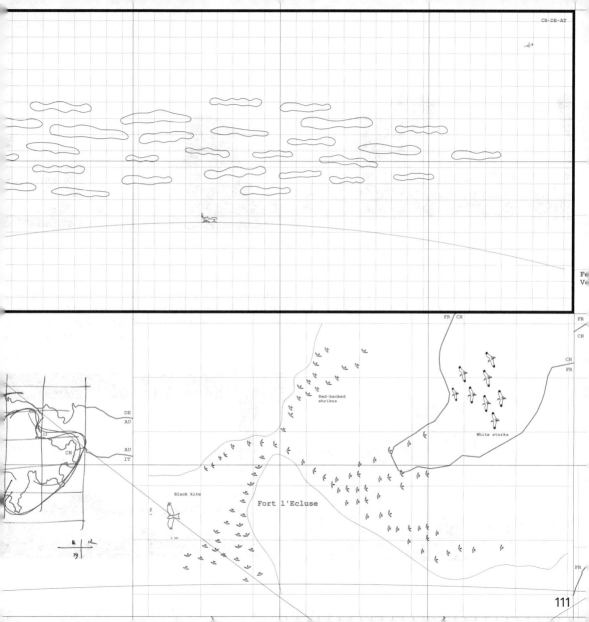

DE
AU

AU
IT

FR / CH

FR

CH

CH
FR

Red-backed
shrikes

White storks

Black kite

Fort l'Ecluse

FR

Fe
Ve

From inside her house, J.K. can see the lake and the sky through the window. "From here, I have...
The sky supplies us with all kinds of stories. The clouds all flow in from somewhere else. Perhaps,..
than those below. It's spectacular in the evening around 8:30, as the last plane flies......................
An illuminated cloud.............

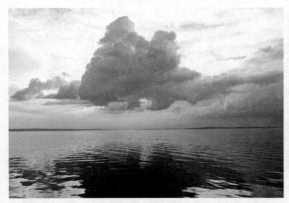

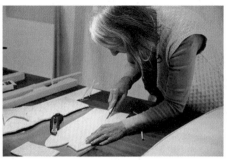

a relationship with the world. There's the **horizon, a segment of the planetary curve.**
............that's why the border doesn't exist for me. The wind pushes those clouds at a higher elevation
.overhead before landing at the airfield. It goes *Wuuuh!* (imitating the sound of an overhead plane).
....that emerges in that way."

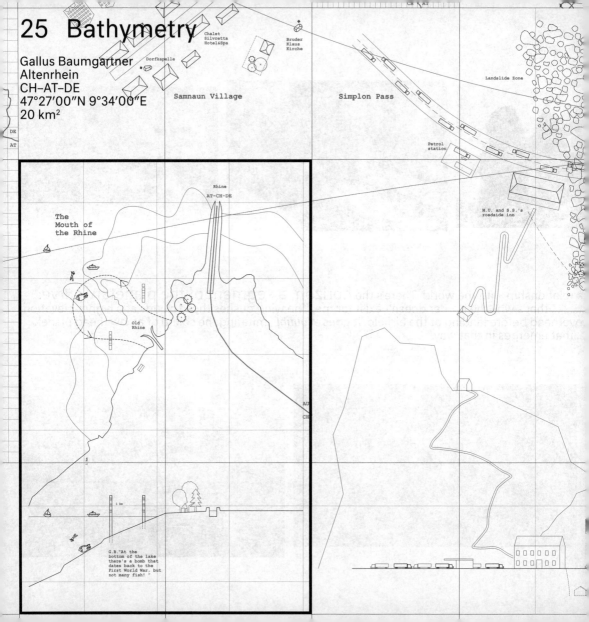

25 Bathymetry

Gallus Baumgartner
Altenrhein
CH–AT–DE
47°27'00"N 9°34'00"E
20 km²

Chalet
Silvretta
Hotel&Spa

Dorfkapelle

Bruder
Klaus
Kirche

Samnaun Village

Simplon Pass

CH AT

Landslide Zone

DE
AT

Petrol
station

M.U. and S.S.'s
roadside inn

Rhine
AT-CH-DE

The
Mouth of
the Rhine

Old
Rhine

AU

CH

1 km

G.B. "At the
bottom of the lake
there's a bomb that
dates back to the
First World War, but
not many fish!"

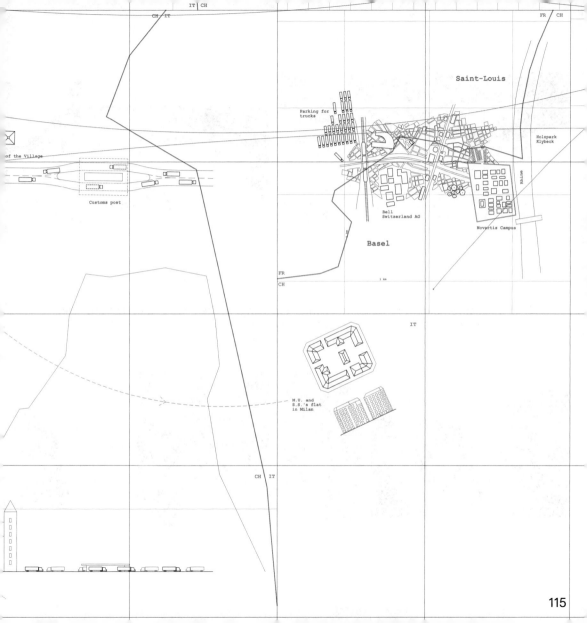

CH | IT

FR | CH

Saint-Louis

Parking for
trucks

Holzpark
Klybeck

of the Village

Rhine

Customs post

Bell
Switzerland AG

Novartis Campus

Basel

FR
CH

1 km

IT

M.U. and
S.S.'s flat
in Milan

CH | IT

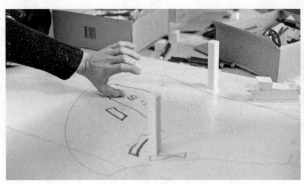 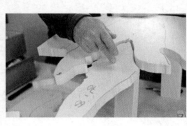

G.B. is the last remaining professional fisherman living on the southern end of the lake..................
Austria and Germany. The rules apply equally for fishing on the surface...........................

 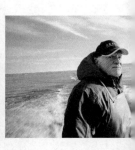

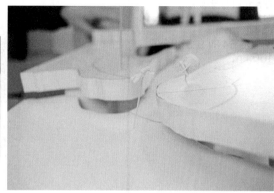

...le fishes at the **mouth of the Rhine**. Commercial fishing is jointly regulated by Switzerland, ...as in the water depths. "Below 25 metres, we hit **international waters**," he says.

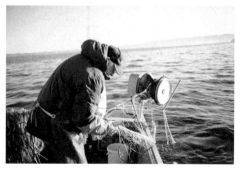

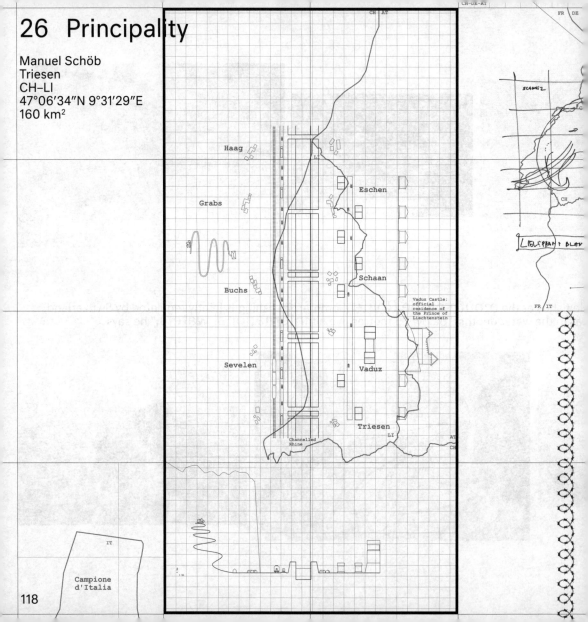

26 Principality

Manuel Schöb
Triesen
CH–LI
47°06'34"N 9°31'29"E
160 km²

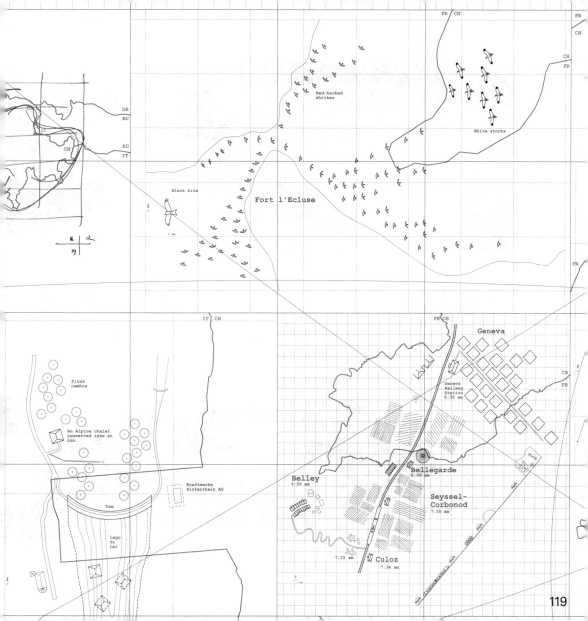

DE
AU

AU
IT

LI

CH

Black kite

Red-backed
shrikes

White storks

Fort l'Ecluse

1 km

IT CH

Pinus
cembra

An Alpine chalet
converted into an
inn.

Kraftwerke
Hinterrhein AG

Dam

Lago
di
Lei

FR CH

FR
CH

CH
FR

FR

CH
FR

FR

Geneva

Geneva
Railway
Station
8:35 am

FR CH

Belley
6:00 am

Bellegarde
8:00 am

Seyssel-
Corbonod
7:50 am

7:25 am

Culoz
7:34 am

119

The **Principality** of Liechtenstein is a constitutional hereditary monarchy covering 160 squar
Its GDP per capita is the second highest in the world, behind that of another principality:......
The **channelled river Rhine** forms the Principality's border with Switzerland as well as a vit
renaturation of the Alpine Rhine has................

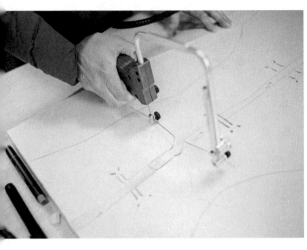

...........kilometres, whose motto is *Für Gott, Fürst und Vaterland* (For God, Prince and Fatherland).
....................Monaco. Its national anthem is *Oben am jungen Rhein* (High on the young Rhine).
.................source for its viable land. M.S. explains that "to date, any question concerning a possible
......remained unanswered by the Principality."

27 Security Fence

Fabio Frison
Kreuzlingen
CH–DE
47°38'45"N 9°10'43"E
64 km²

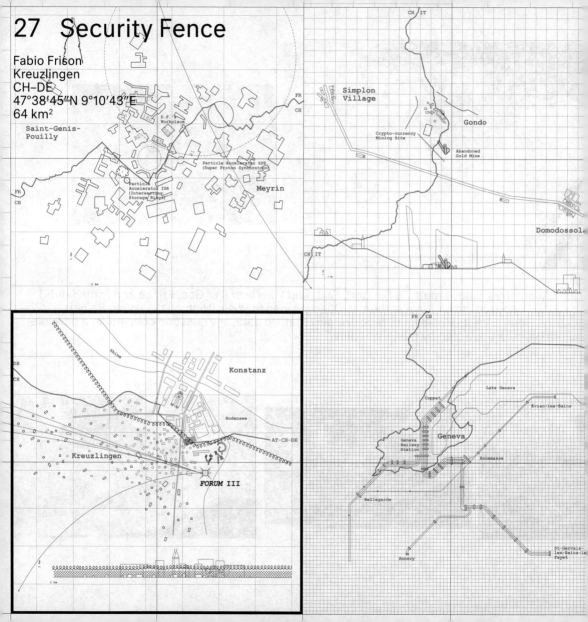

The housing estate was
designed by Bruno Giacometti

The Chestnut Grove

Gottfried Semper designed the
Villa Garbald; Miller &
Maranta were responsible for
its extension and renovation.

Castasegna

The customs post was designed
by Bruno Giacometti

IT CH

Shopping Mall

FR DE

Saint-Louis

Basler
Münster

FR
CH 1 km

IT CH

123

HÜSLIPÄSCHT

Constance and Kreuzlingen form a single urban agglomeration. During the Second World War,......
German Reich from Switzerland. Crossings points have since been created through that fence...........
of art. During the Covid-19 pandemic, the media began to take a deep interest in this borde
"prevent crossborder infections," as per a.............

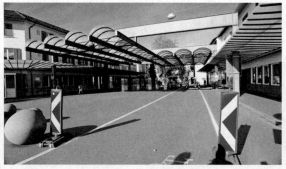

SWR» AKTUELL

SWR > SWR Aktuell > Baden-Württemberg > Friedrichshafen

ZWEITER ZAUN IN KONSTANZ AUFGESTELLT

Weitere Absperrung hält Paare an Deutsch-Schweizer
Grenze auf Distanz

Bislang konnten sich Liebespaare, bei denen eine Person in Deutschland und die
andere in der Schweiz lebt, in Konstanz an einem Sperrzaun treffen, um in

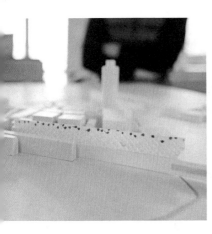
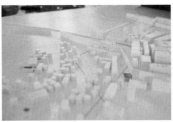

.........a **fence reinforced with barbed wire** was erected along the border to separate the
..............At these crossings, vestiges of the fence have been converted into **monumental works**
.........................Two brand-new **350-metre-long fences** were installed there in order to
statement by the Kreuzlingen health authorities.

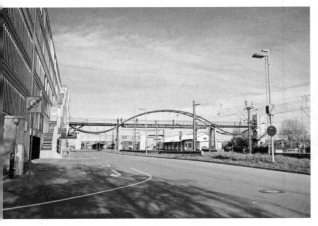

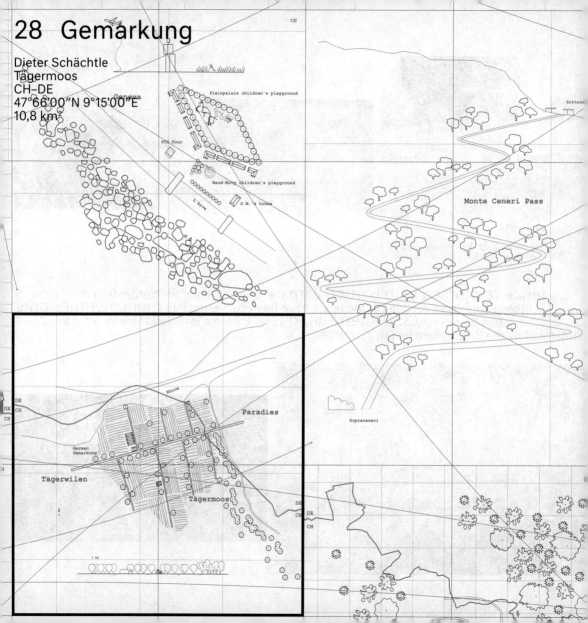

28 Gemärkung

Dieter Schächtle
Tägermoos
CH–DE
47°66'00"N 9°15'00"E
10,8 km²

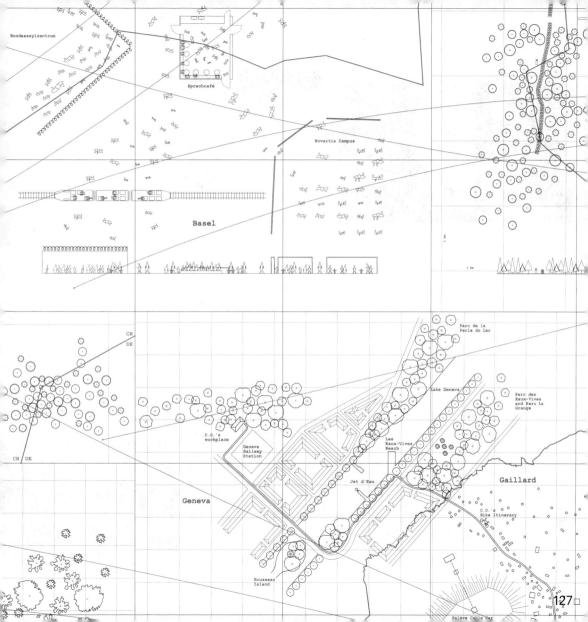

Bundesasylzentrum

Sprachcafé

Novartis Campus

Basel

1 km

CH
DE

CH DE

Parc de la
Perle du Lac

Lake Geneva

Parc des
Eaux-Vives
and Parc La
Grange

C.O.'s
workplace

Geneva
Railway
Station

Les
Eaux-Vives
Beach

Jet d'Eau

Gaillard

C.O.'s
Bike Itinerary

Geneva

Rousseau
Island

Salève Cable Car

127

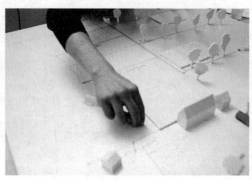

The **agricultural lands** located on Swiss territory are administered by the German city......
which renders this area a German *Gemarkung*, a local sub-district. This legal status
Constance legally owns about two thirds of the land; it is primarily used for allotments by the.........

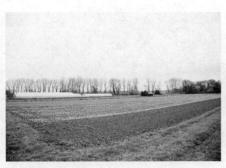

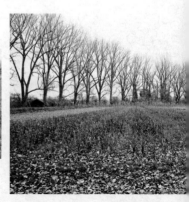

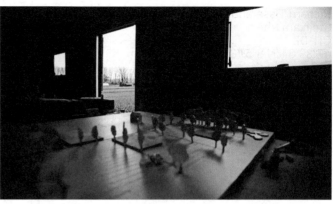

of Constance. It exercises certain official tasks, notably the administration of the land register,was established by a bilateral treaty signed in 1831 and remains in force to this day. city's residents as well as for **vegetable production destined for the Swiss market.**

29 Grüne Grenze

Richard Tisserand
Stein am Rhein
CH–DE
47°39'34"N 8°51'33"E
182 km²

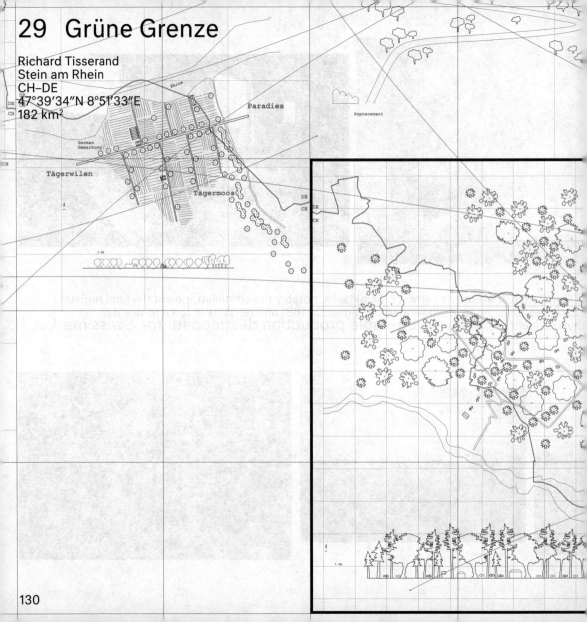

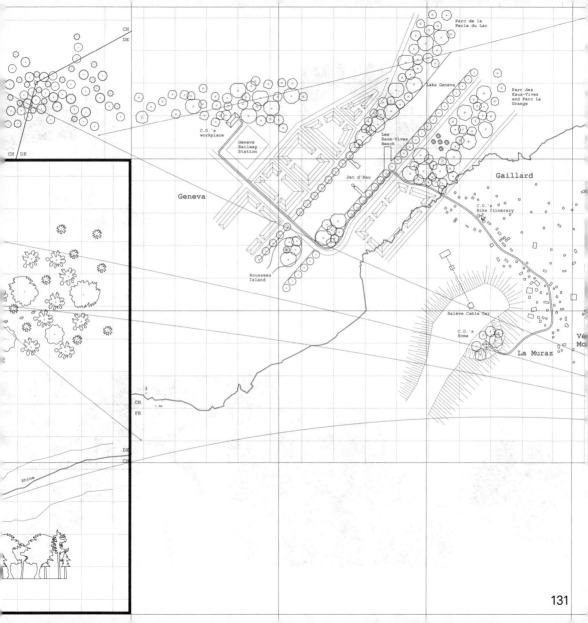

Parc de la
Perle du Lac

Lake Geneva

Parc des
Eaux-Vives
and Parc La
Grange

CH
DE

C.O.'s
workplace

Geneva
Railway
Station

Les
Eaux-Vives
Beach

Gaillard

CH DE

Geneva

Jet d'Eau

C.O.'s
Bike Itinerary

Rousseau
Island

Salève Cable Car

C.O.'s
Home

La Muraz

Vé
Mo

CH
FR

1 km

DE
CH

Rhine

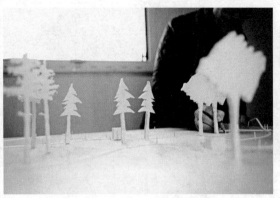 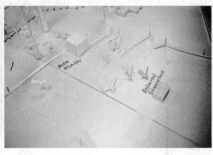

The term *Grüne Grenze* (green border) designates a section of border covered by forest, fiel[
the *Grüne Grenze* has been historically associated with illegal border crossings by smugglers...
connotes a demarcation line, and is equated with battle fronts arising from military.
The term "Green Zone" refers to the........

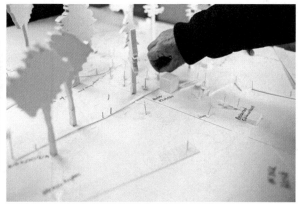

......and clearings, which renders it challenging to monitor. In Europe, the act of passing through
................as well as by political activists and refugees. In the Arab world, the term "Green Line"
.....conflicts. Green Lines are to be found in the Palestinian Territories and Lebanon.
.........highly secured enclave in Baghdad.

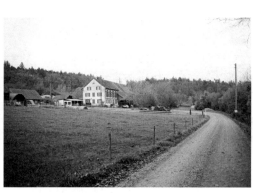
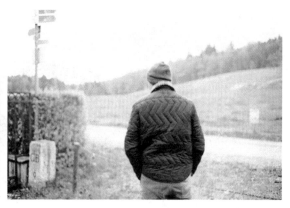

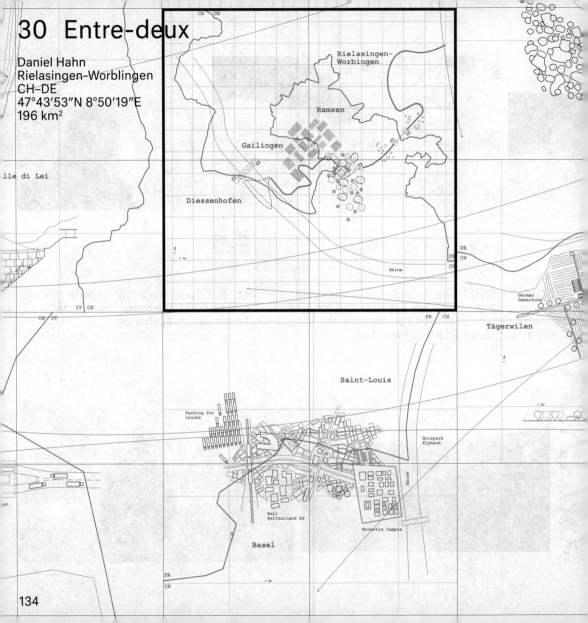

30 Entre-deux

Daniel Hahn
Rielasingen-Worblingen
CH–DE
47°43′53″N 8°50′19″E
196 km²

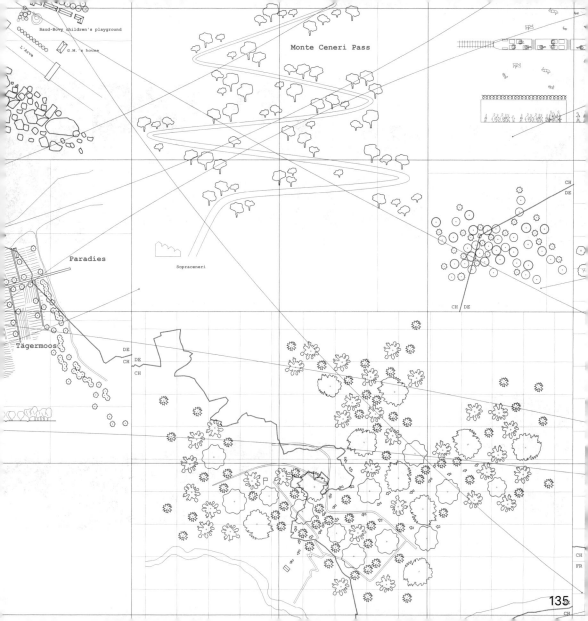

Baud-Bovy children's playground

L'Arve

G.M.'s house

Monte Ceneri Pass

Paradies

Sopraceneri

Tägermoos

CH
DE

DE
CH DE
CH

CH / DE

DE
CH

P

135

CH
FR

CH

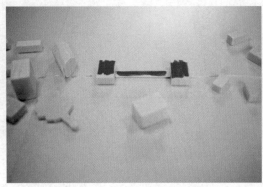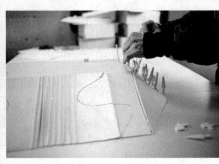

D.H. has to cross the border three times and pass through six custom posts in order to go..........
on ne sait jamais vraiment où on est. On éprouve un sentiment d'incertitude permanente"..
One feels a constant.......

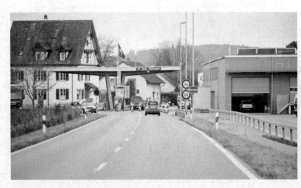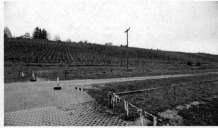

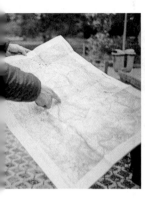
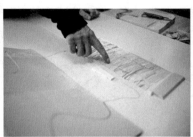

.swimming in the Rhine, some 15 km from his home. *"Dans l'espace situé entre deux douanes,*
..(In that space between two customs posts, you never really know where you are.
.......sense of uncertainty.)

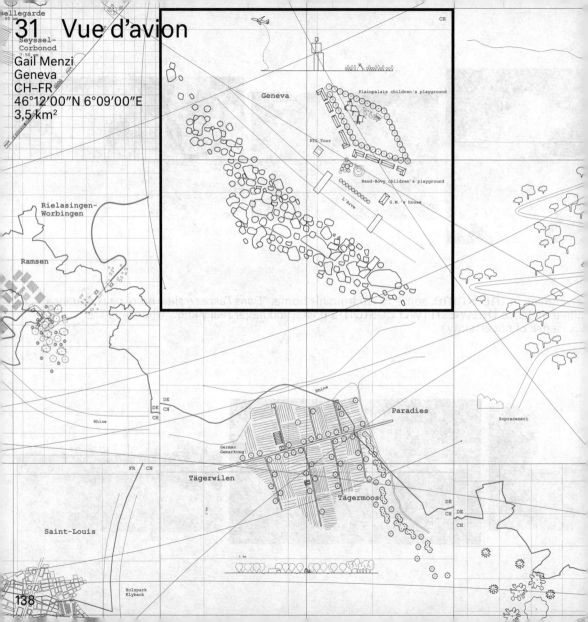

31 Vue d'avion

Gail Menzi
Geneva
CH–FR
46°12′00″N 6°09′00″E
3,5 km²

Geneva

Plainpalais children's playground

RTS Tour

Baud-Bovy children's playground

L'Arve

G.M.'s house

Rielasingen-
Worbingen

Ramsen

Rhine

DE
CH

DE
CH

Rhine

German
Gemarkung

FR / CH

Tägerwilen

Paradies

Sopraceneri

Tägermoos

DE
CH

DE
CH

Saint-Louis

1 km

Holzpark
Klybeck

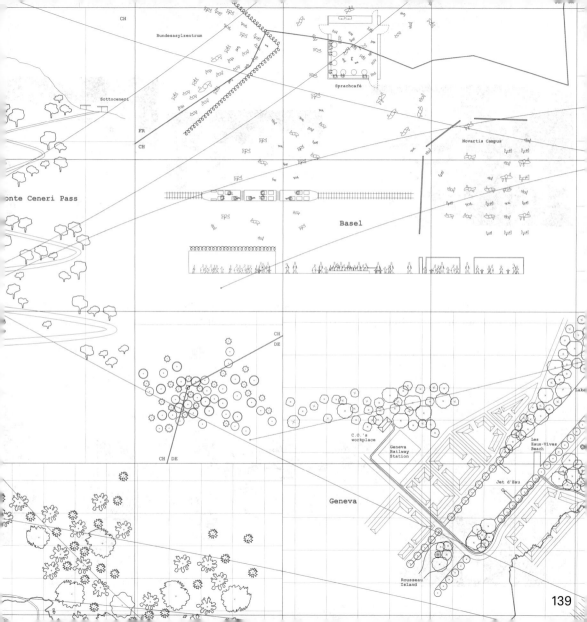

CH

Bundesasylzentrum

Sprachcafé

Sottoceneri

FR
CH

Novartis Campus

onte Ceneri Pass

Basel

CH
DE

C.O.'s
workplace

Geneva
Railway
Station

Les
Eaux-Vives
Beach

CH DE

Lake

Geneva

Jet d'Eau

Rousseau
Island

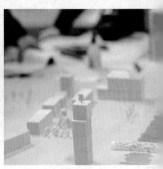

G.M. is the foster parent of an undocumented child. From his kitchen, the child......
The foster-mother and her child go out to play in the neighbourhood children's...........................

watches **planes** in the sky and the facade of a **glass tower** reflecting the sun.
...playgrounds. They don't stray far away. They can't cross the border for fear of being detained.

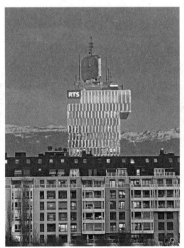
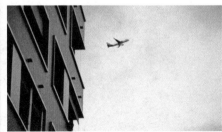

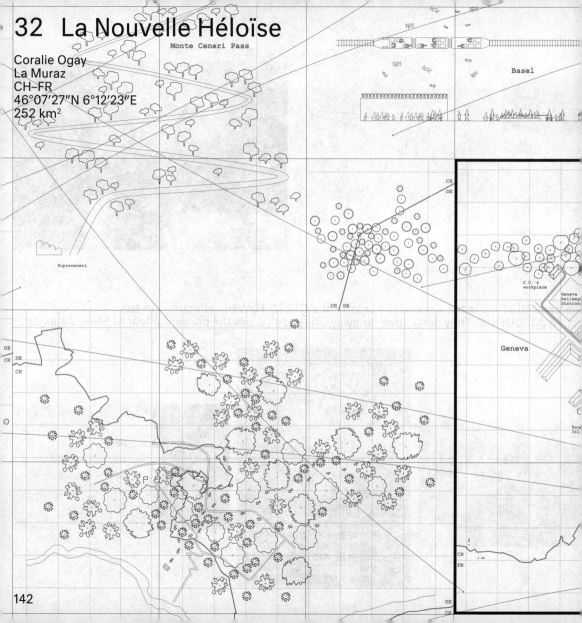

32 La Nouvelle Héloïse

Monte Ceneri Pass

Coralie Ogay
La Muraz
CH–FR
46°07′27″N 6°12′23″E
252 km²

Basel

CH
DE

Supraceneri

CH / DE

CH
DE
CH
DE
CH

C.O.'s
workplace

Geneva
Railway
Station

Geneva

Rou
Isl

CH
FR

DE
CH

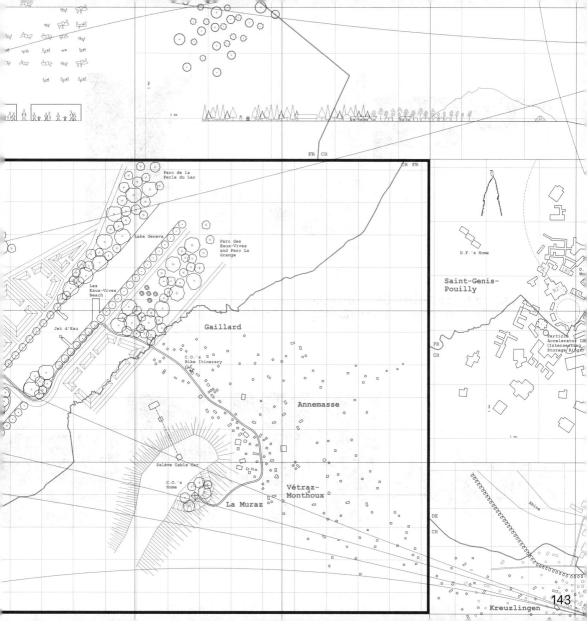

Parc de la
Perle du Lac

Lake Geneva

Parc des
Eaux-Vives
and Parc La
Grange

Les
Eaux-Vives
Beach

Jet d'Eau

Gaillard

C.O.'s
Bike Itinerary

Annemasse

Salève Cable Car

C.O.'s
Home

Vétraz-
Monthoux

La Muraz

FR CH
CH FR

D.F.'s Home

Saint-Genis-
Pouilly

D.
Wo

Particle
Accelerator IS
(Intersecting
Storage Ring)

FR
CH

DE
CH

Rhine

1 km

1 km

1 km

143

Kreuzlingen

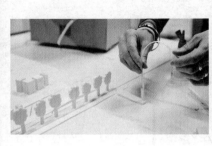 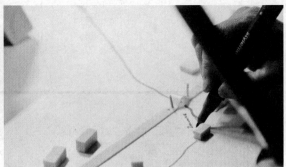

C.O. moved out to the suburbs so that she could be, as she put it, "closer to nature." She works...
On leaving home, she describes "grey buildings and sheds." As she gets nearer...
she heaves a sigh of relief...

 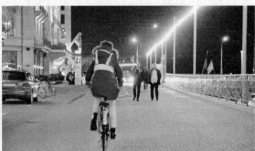 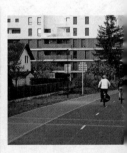

...n the other side of the border, in downtown Geneva. Every day, she makes that journey by bike.the city centre, she talks about "green spaces and large trees." Whereupon, . "*Ah ! enfin la nature.*" (Ah, nature at long last!)

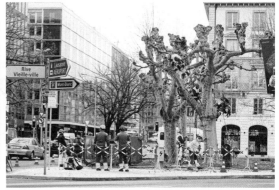

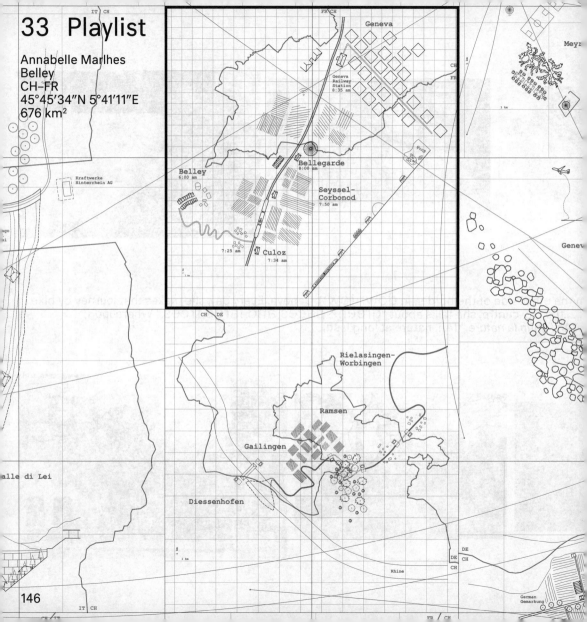

33 Playlist

Annabelle Marlhes
Belley
CH–FR
45°45'34"N 5°41'11"E
676 km²

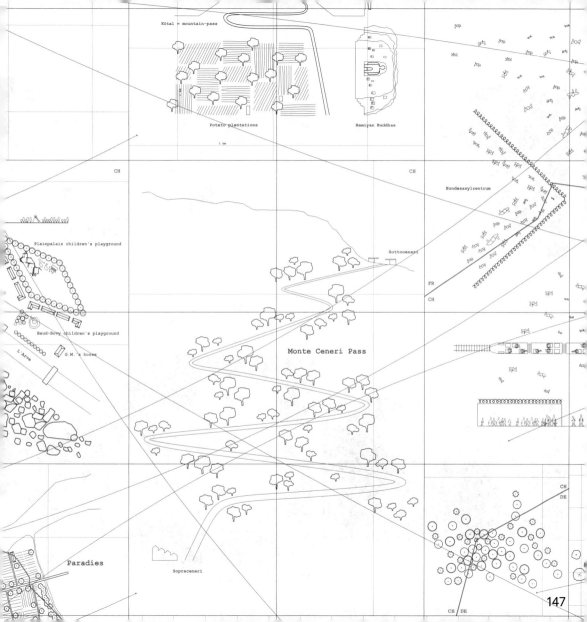

Kōtal = mountain-pass

Potato plantations

Bamiyan Buddhas

1 km

CH

CH

Bundesasylzentrum

Plainpalais children's playground

Sottoceneri

FR

CH

Baud-Bovy children's playground

Monte Ceneri Pass

L'Arve

G.M.'s house

CH
DE

Paradies

Sopraceneri

CH / DE

147

Every day, A.M. crosses the border by train to get to Geneva where she studies
her journey is punctuated by the music she listens to on her smartphone playlist....

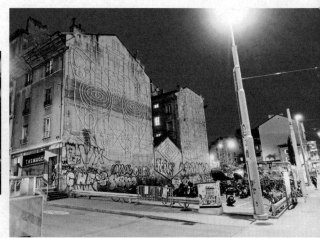

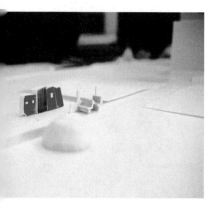

...musicology. The **commute** takes 59 minutes. From her home to the school,
..............Each place she passes through precisely corresponds to a piece of music.

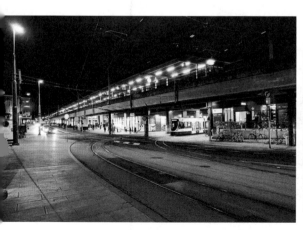

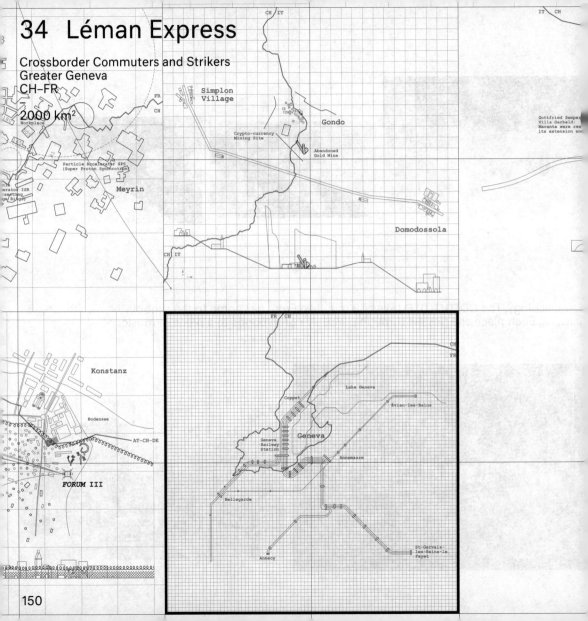

34 Léman Express

Crossborder Commuters and Strikers
Greater Geneva
CH–FR

2000 km²

Workplace

FR
CH

Particle Accelerator SPS
(Super Proton Synchrotron)

Meyrin

Simplon
Village

Crypto-currency
Mining Site

Gondo

Abandoned
Gold Mine

CH IT

CH IT

Domodossola

IT CH

Gottfried Semper
Villa Garbald:
Maranta were res
its extension an

erator ISR
earching
ge/Ring)

Konstanz

Bodensee

AT-CH-DE

FORUM III

FR CH

Coppet

Lake Geneva

Evian-les-Bains

Geneva
Railway
Station

Geneva

Annemasse

Bellegarde

Annecy

St-Gervais-
les-Bains-le
Fayet

CH
FR

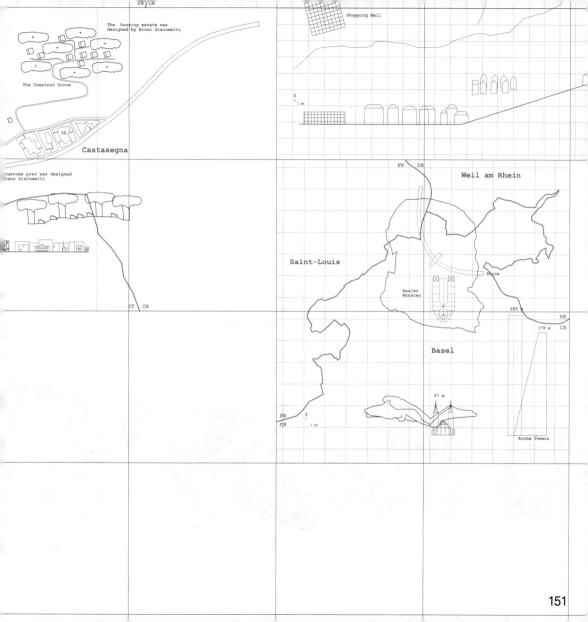

The housing estate was
designed by Bruno Giacometti

The Chestnut Grove

Castasegna

Shopping Mall

customs post was designed
Bruno Giacometti

IT CH

FR DE

Weil am Rhein

Saint-Louis

Rhine

Basler
Münster

205 m

DE
CH

178 m

Basel

67 m

FR
CH

Roche Towers

The Léman Express (LEX) is a **commuter railway network** for the transborder agglomeratio
whose lines all converge in Geneva's city centre. This radio-centric structure is meant to........
On the day LEX was inaugurated, French employees took industrial action:.............................
within the zone of influence of the Lake Geneva

........................of Greater Geneva, serving forty-five stations on either side of the Franco-Swiss border,
..........facilitate crossborder workers access to the economic hubs located in Greater Geneva.
...they went on strike, demanding an increased cost-of-living allowance for those working
..metropolis, and yet who can't reap its benefits.

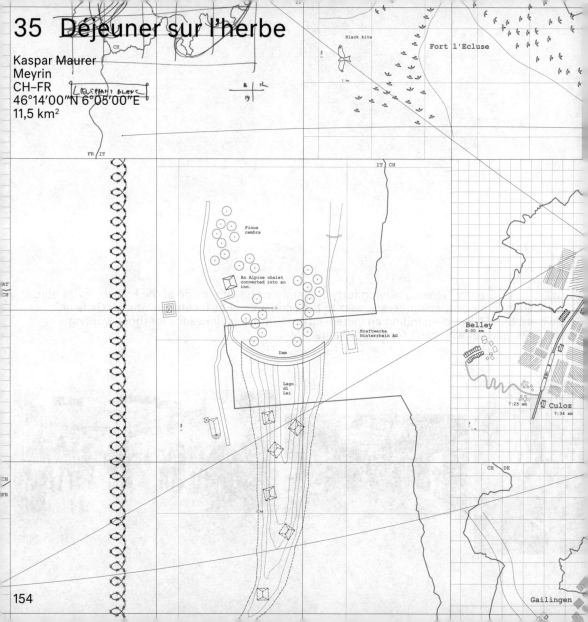

35 Déjeuner sur l'herbe

Kaspar Maurer
Meyrin
CH–FR
46°14′00″N 6°05′00″E
11,5 km²

Black kite

Fort l'Ecluse

Pinus
cembra

An Alpine chalet
converted into an
inn.

Kraftwerke
Hinterrhein AG

Dam

Lago
di
Lei

Belley
6:00 am

7:25 am

Culoz
7:34 am

CH DE

Gailingen

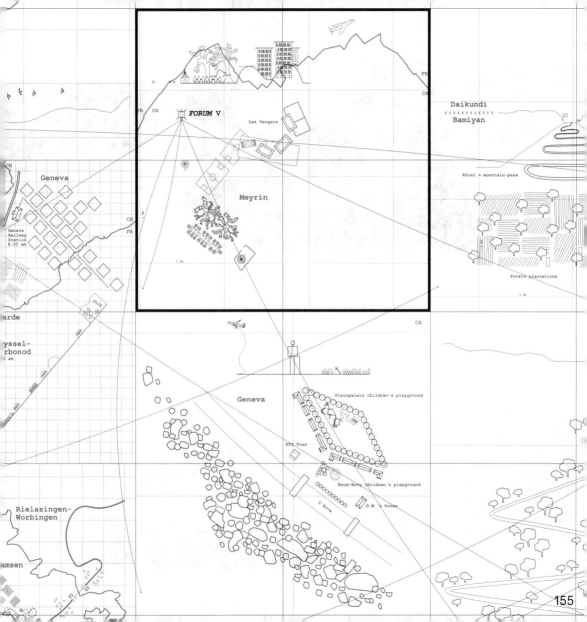

FORUM V

Les Vergers

Meyrin

1 km

Daikundi
x x x x x x x x x x x x
Bamiyan

Kötal = mountain-pass

Potato plantations

1 km

Geneva

Geneva
Railway
Station
8:35 am

arde

yssel-
rbonod
0 am

Geneva

Plainpalais children's playground

RTS Tour

Baud-Bovy children's playground

L'Arve

G.M.'s house

Rielasingen-
Worbingen

amsen

155

Some years ago, a few people were enjoying a picnic, sitting on the grass, away from the city,..
They were discussing a cooperative housing project. Today, at that very site where they..
the eco-neighbourhood..........

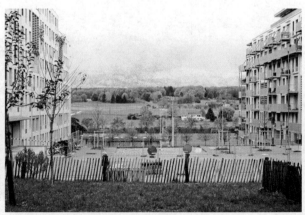

.close to the border. Around them, no buildings; nothing other than fields and an orchard.
.....picnicked, are to be found thirty buildings and more than 1350 dwellings for 3000 inhabitants:
is called *Les Vergers* (The Orchards).

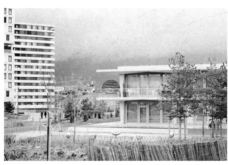

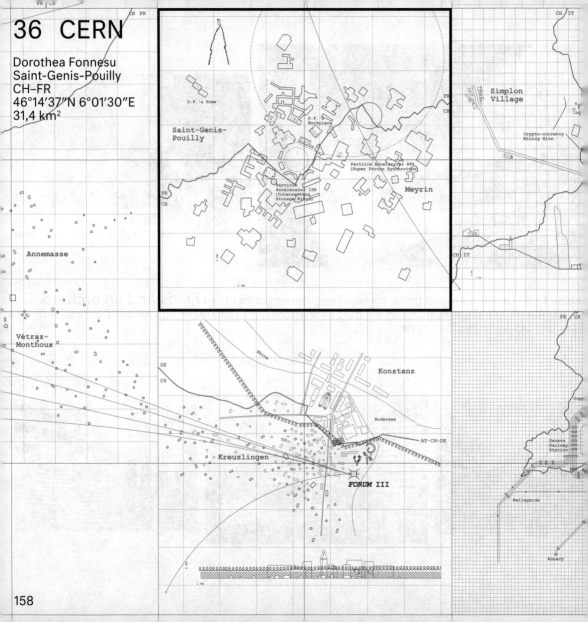

36 CERN

Dorothea Fonnesu
Saint-Genis-Pouilly
CH–FR
46°14′37″N 6°01′30″E
31,4 km²

D.F.'s Home

Saint-Genis-
Pouilly

D.F.'s
Workplace

Particle Accelerator SPS
(Super Proton Synchrotron)

Particle
Accelerator ISR
(Intersecting
Storage Rings)

Meyrin

Annemasse

Simplon
Village

Crypto-currency
Mining Site

Vétraz-
Monthoux

DE
CH

Rhine

Konstanz

Bodensee

AT-CH-DE

Kreuzlingen

FORUM III

FR CH

Geneva
Railway
Station

Copp

Bellegarde

Annecy

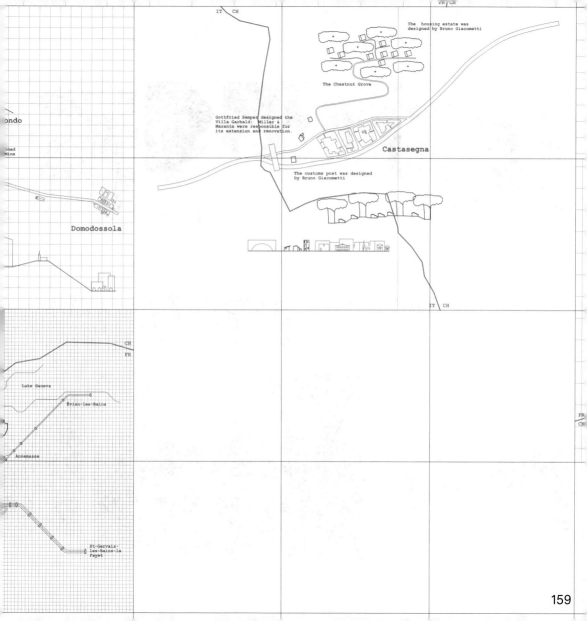

The housing estate was
designed by Bruno Giacometti

The Chestnut Grove

Gottfried Semper designed the
Villa Garbald; Miller &
Maranta were responsible for
its extension and renovation.

Castasegna

The customs post was designed
by Bruno Giacometti

ondo

oned
Mine

Domodossola

IT CH

CH
FR

Lake Geneva

Évian-les-Bains

Annemasse

FR
CH

St-Gervais-
les-Bains-le
Fayet

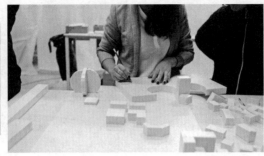

Located on and under the Franco-Swiss border, CERN, the European Organisation
The rings for the particle accelerators, some of which are kilometres...
She works in a numbered hangar and lives in a tower-block on...
From her apartment she can see mountains,..............

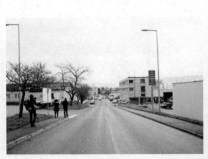

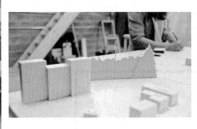

.............for Nuclear Research operates the world's largest particle physics laboratory.
.............in diameter, were built one hundred meters underground. D.F. is a physicist.
the French side of the border. Her movements are limited to her work.
..a large tree and a bird perched on top.

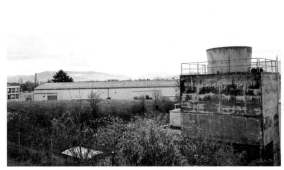

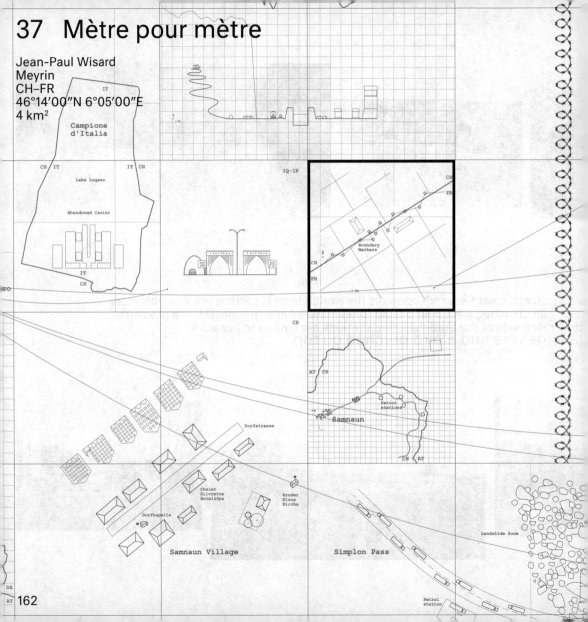

37 Mètre pour mètre

Jean-Paul Wisard
Meyrin
CH–FR
46°14′00″N 6°05′00″E
4 km²

Campione
d'Italia

CH IT IT CH

Lake Lugano

Abandoned Casino

IT

CH

SO

IQ-IR

CH

FR

CH

FR

Boundary
Markers

1 km

CH

AT CH

Petrol
stations

Samnaun

CH AT

Dorfstrasse

Chalet
Silvretta
Hotel&Spa

Bruder
Klaus
Kirche

Dorfkapelle

Landslide Zone

Samnaun Village

Simplon Pass

Petrol
station

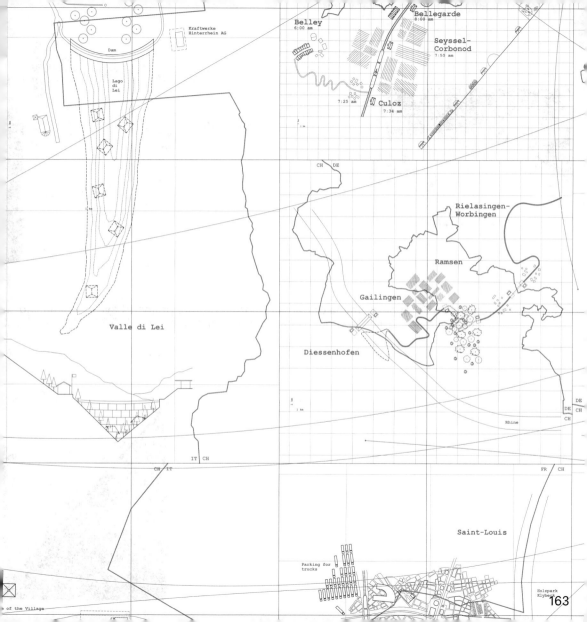

Kraftwerke
Hinterrhein AG

Dam

Lago
di
Lei

Valle di Lei

IT CH

CH IT

e of the Village

Belley
6:00 am

Bellegarde
8:00 am

Seyssel-
Corbonod
7:50 am

7:25 am

Culoz
7:34 am

CH DE

Rielasingen-
Worbingen

Ramsen

Gailingen

Diessenhofen

DE
CH

DE
CH

Rhine

FR CH

Saint-Louis

Parking for
trucks

Holzpark
Klybeck

163

Climatic fluctuations, natural phenomena or transport infrastructure projects have been causing.....
stick to a golden rule: "No country can increase or reduce the surface area of......

...borders to displace. Surveyors in charge of measuring and delineating **national boundaries** .its territory." Every square metre lost in one location must be regained elsewhere.

38 La Bétaillère

Transborder Commuters
Lake Geneva
CH–FR
46°26′00″N 6°33′00″E
580 km²

CH
IT

CH IT

Brig

Simplon
Tunnel

Iselle di
Trasquera

BLS Car Transport Train

Domodo

IT CH

Motel

CH
IT

Stabio

1 km

Customs

CH IT

Punto
Fresco

FR DE

Silvretta Arena
Ischgl-Samnaun Ski
Resort

MPreis

Alptrider
Sattel

Vitra Campus
M.Z.'s workplace

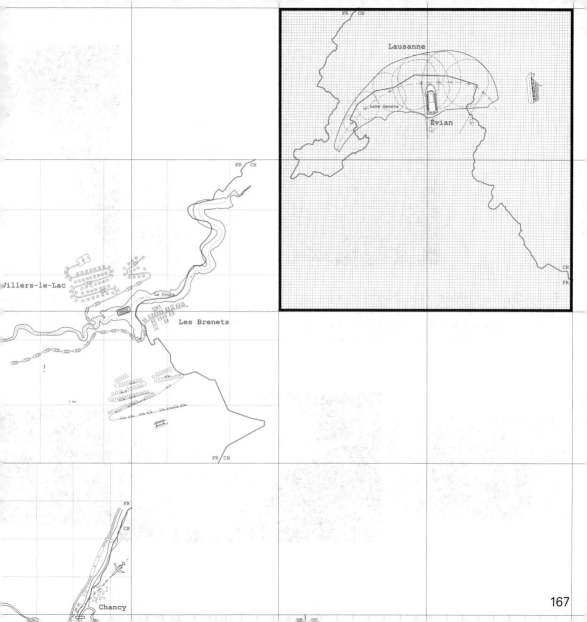

Villers-le-Lac

Le Doubs

Les Brenets

Lausanne

Lake Geneva

Évian

FR CH

FR CH

FR CH

FR CH

CH
FR

FR
CH

Chancy

167

Every day, hundreds of crossborder commuters cross **Lake Geneva** by ferry to their workplaces
cramped. Outside, on the horizon of the vast body of water, lies Lausanne. J.G. states: *"Vous savez*
en France le matin. Elle a construit un bateau que l'on surnomme La Bétaillère. D'ailleurs, je crois......
commuters, of those taking the boat in France each morning. It built a boat..............

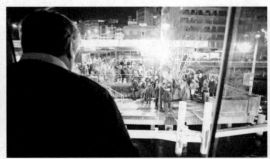

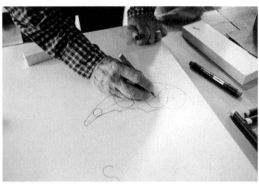

.....On the **quayside, queues** to board and alight the **ferry** are long. On board, passengers are *la compagnie de navigation profite du trafic des frontaliers, ceux qui prennent le bateau**qu'elle en a même deux."* (You know, the shipping company takes advantage of crossborder known as *La Bétaillère* (cattle-wagon). In fact, I think it even runs two of them.)

39 Route douanière

Jean-Paul Wisard
Ferney-Voltaire
CH–FR
46°15′21″N 6°06′29″E
14,3 km²

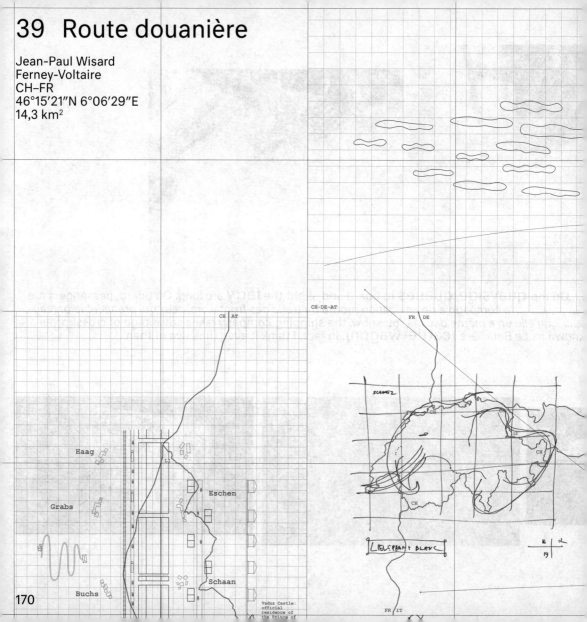

Haag

Grabs

Eschen

Buchs

Schaan

CH–AT

CH–DE–AT

FR–DE

FR–IT

SCHWIZ

L'ÉLÉPHANT BLANC

Vaduz Castle:
official
residence of
the Prince of

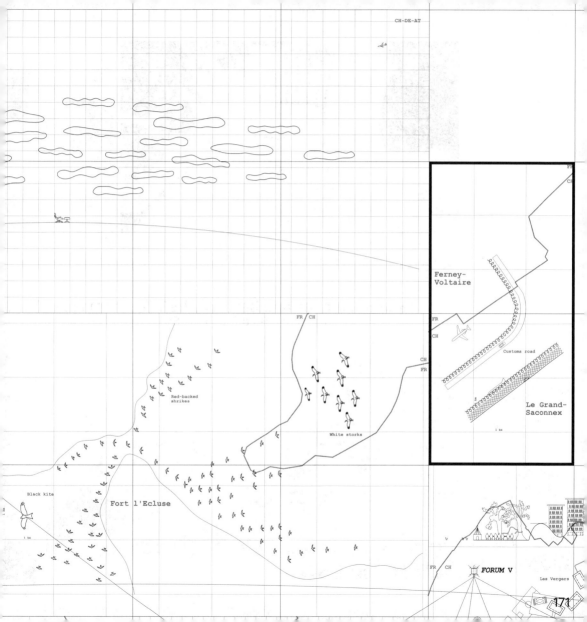

CH-DE-AT

Ferney-
Voltaire

FR
CH

CH
FR

Customs road

Le Grand-
Saconnex

1 km

FR CH

Red-backed
shrikes

White storks

Black kite

Fort l'Ecluse

1 km

FR CH

FORUM V

Les Vergers

171

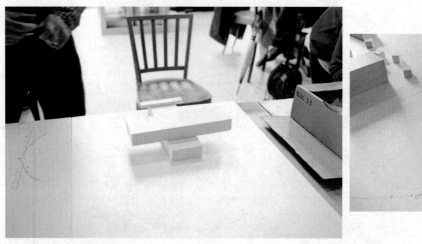

Secured by **fences and barbed wire**, a **"customs road"**..........
users to pass through the Swiss territory on which it.........

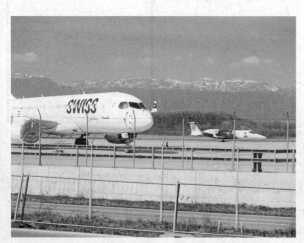
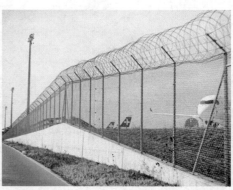

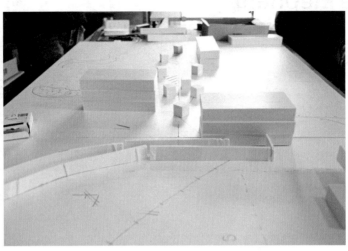

.....offers access to Geneva's Cointrin airport without entailing its various
was built. It is an extra-territorial transport infrastructure.

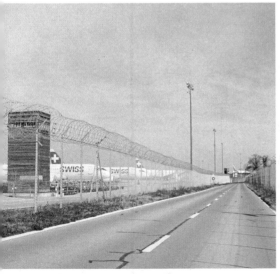

40 White Elephant

Jacques Gubler
Switzerland
CH–DE–FR–IT–AU–LI
–
41 285 km²

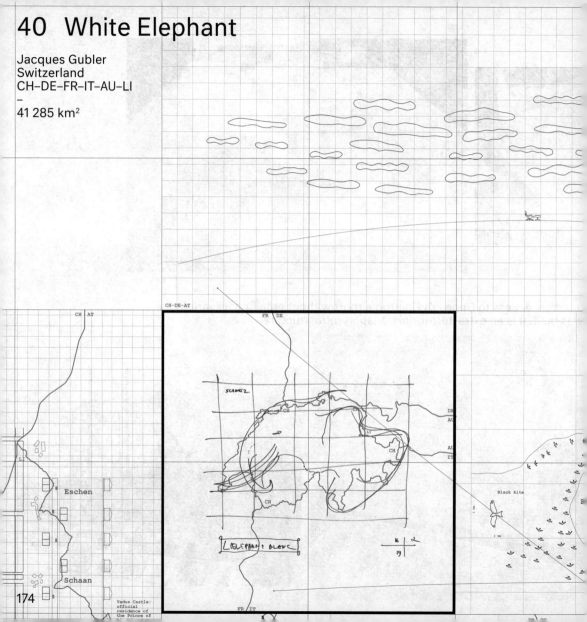

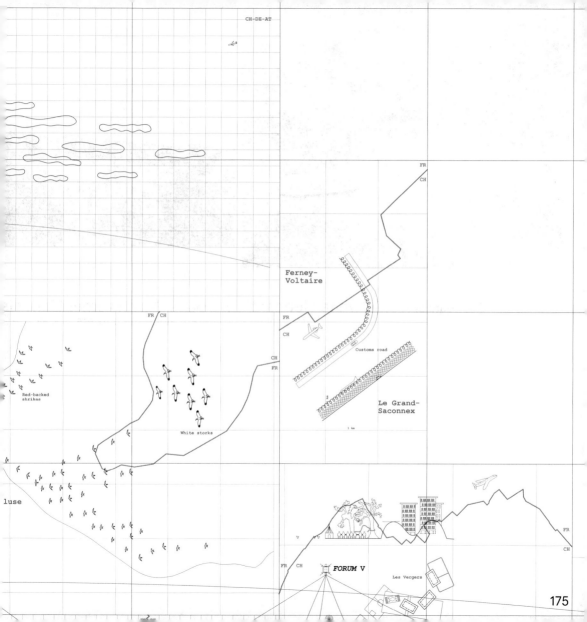

CH-DE-AT

Ferney-
Voltaire

FR

CH

FR

CH

FR / CH

FR

CH

CH

FR

Customs road

Le Grand-
Saconnex

1 km

Red-backed
shrikes

White storks

luse

FR CH

FORUM V

Les Vergers

FR

CH

175

The figure of speech "white elephant" designates an "achievement" that is
Such projects proliferate along the borders. Today, the...

..........more costly than beneficial, perfectly useless and difficult to dispose of.
...................border itself might even be a white elephant.

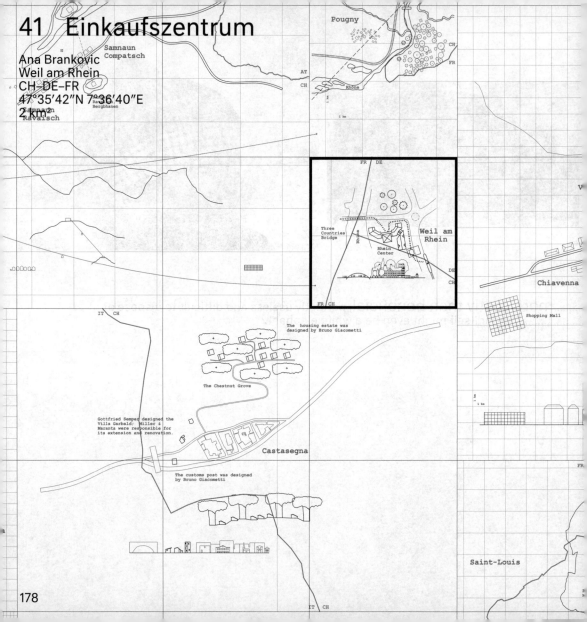

41 Einkaufszentrum

Ana Brankovic
Weil am Rhein
CH–DE–FR
47°35'42"N 7°36'40"E
2 km

Pougny

Samnaun
Compatsch

Samnaun
Ravaisch

Rhône

AT
CH

FR
DE

Three
Countries
Bridge

Rhein
Center

Weil am
Rhein

DE
CH

FR CH

V

Chiavenna

Shopping Mall

IT CH

The housing estate was
designed by Bruno Giacometti

The Chestnut Grove

Gottfried Semper designed the
Villa Garbald; Miller &
Maranta were responsible for
its extension and renovation.

Castasegna

The customs post was designed
by Bruno Giacometti

Saint-Louis

IT CH

CH

Hotel

Saint - Moritz

Hotel

Stampa

Castasegna

hiavenna

CH

IT

Weil am Rhein

Rhine

205

DE

179

There is a large-scale shopping centre behind the 1980s postmodern facades................................
can be accessed on foot via the Three Countries Bridge. Most people, however, get there......

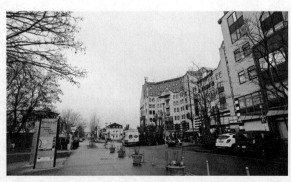

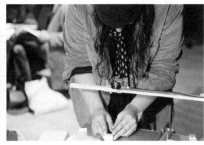

Located at that point where the Swiss, French, and Germans borders converge, the **Rhein Center**by tram or by car. Large queues constantly form at the tram stop or at the duty-free counters.

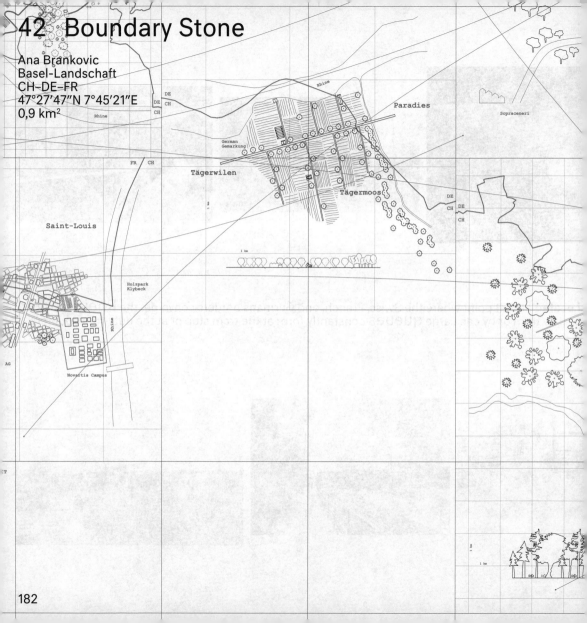

42 Boundary Stone

Ana Brankovic
Basel-Landschaft
CH–DE–FR
47°27'47"N 7°45'21"E
0,9 km²

Rhine

DE
CH

DE
CH

Rhine

German
Gemarkung

FR CH

Tägerwilen

Saint-Louis

Holzpark
Klybeck

Rhine

AG

Novartis Campus

Rhine

Paradies

Sopraceneri

DE
CH DE
CH

Tägermoos

1 km

1 km

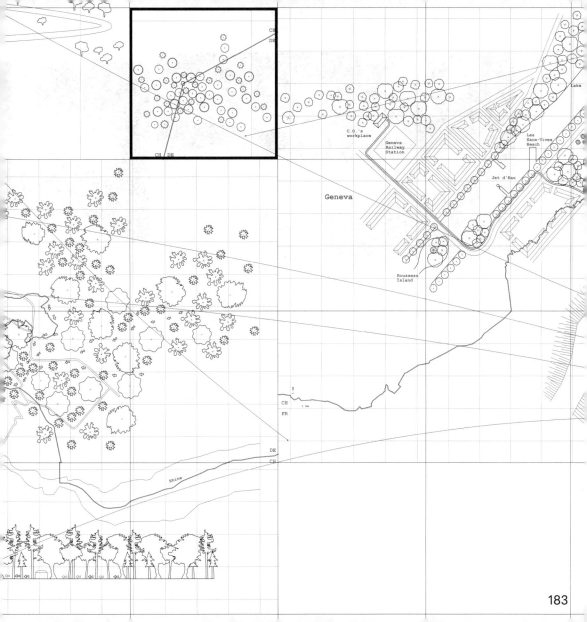

CH
DE

CH DE

Lake

C.O.'s
workplace

Geneva Railway
Station

Les
Eaux-Vives
Beach

Jet d'Eau

Geneva

Rousseau
Island

CH
FR

1 km

DE
CH

Rhine

183

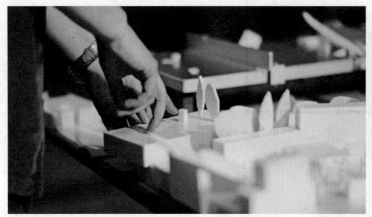

A **boundary stone** identifies the point where border lines intersect. Generally
of which it remains the indivisible property. A groove etched into the top of the stone
and latitudinal coordinates rather than any physical demarcation in the..............

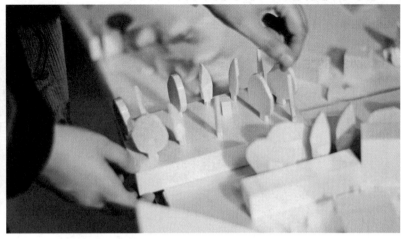

....it consists of a stone bearing the coats-of-arms of the two adjoining countries,indicates the border's contours. Nowadays, precedence is given to longitudinal .terrain. Boundary markers have become **objects of heritage worship**.

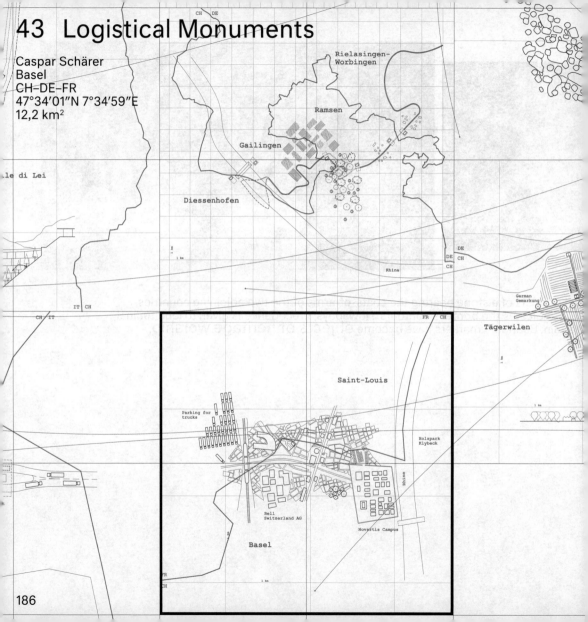

43 Logistical Monuments

Caspar Schärer
Basel
CH–DE–FR
47°34'01"N 7°34'59"E
12,2 km²

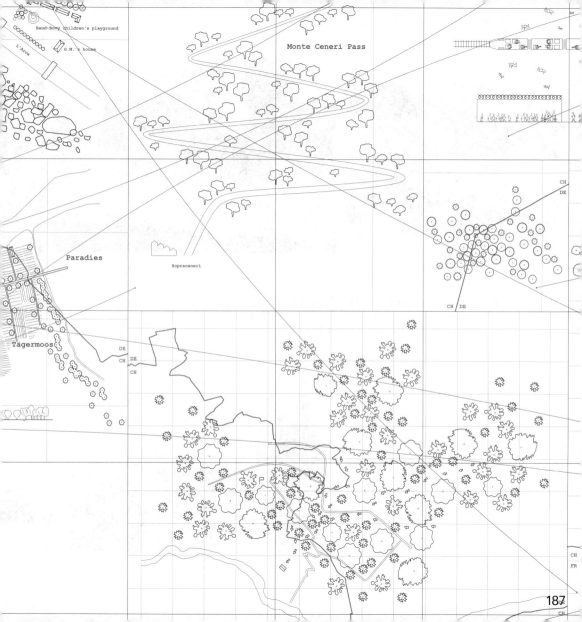

Baud-Bovy children's playground

L'Arve

G.M.'s house

Monte Ceneri Pass

Paradies

Sopraceneri

Tägermoos

DE
CH DE
CH

CH
DE

CH DE

CH
FR

CH

187

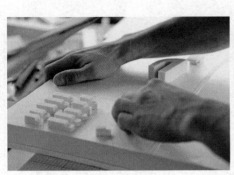
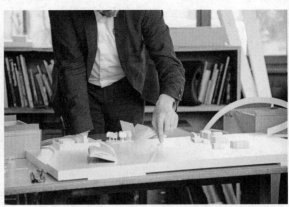

Situated at a short distance from each other, one finds a river port, a dry port, several.........
a sausage factory, an international art fair, and wastelands used
is not so much the sites in themselves, but rather their unlikely juxtaposition...

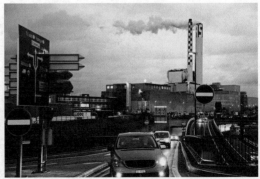

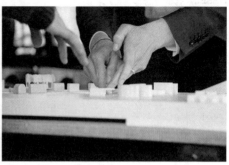

pharmaceutical campuses, chemical industries, a **waste treatment plant,**
.....for cultural purposes. What makes the whole thing so incongruous
............This neighbourhood has only been made possible thanks to the border.

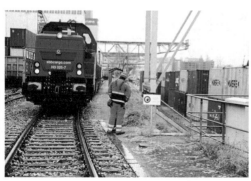

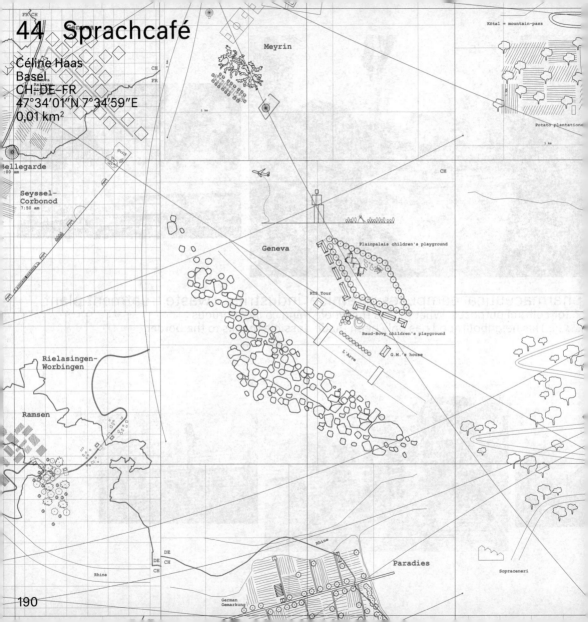

44 Sprachcafé

Céline Haas
Basel
CH–DE–FR
47°34′01″N 7°34′59″E
0,01 km²

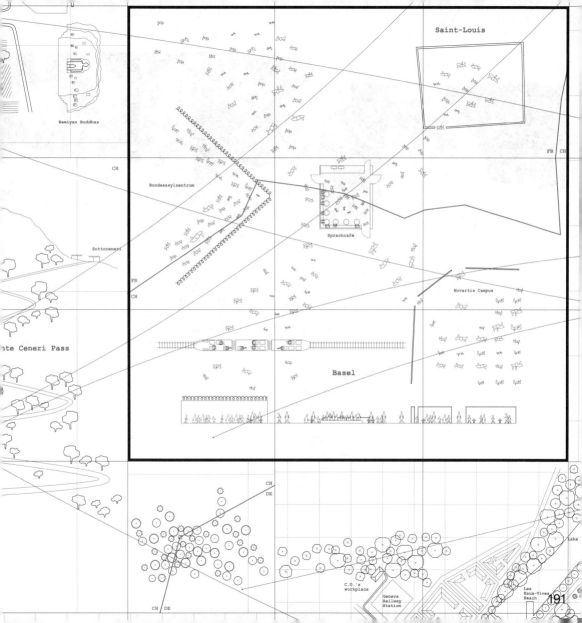

Saint-Louis

Bamiyan Buddhas

FR CH

CH

Bundesasylzentrum

Sottoceneri

FR
CH

Sprachcafé

Novartis Campus

nte Ceneri Pass

Basel

CH
DE

Lake

C.O.'s
workplace

Geneva
Railway
Station

Les
Eaux-Vives
Beach

CH DE

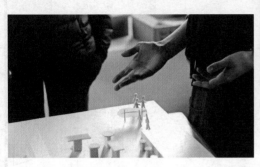
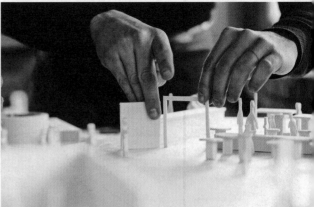

A *Sprachcafé* designates a social space for integrating into one's host socie
it represents a space "open to all city residents, as well as to crossborder commuters,
"Our *Sprachcafé* makes a deliberate effort to engage with people from as many...........
In a relaxed and informal atmosphere, asylum seekers, migrants and all others learning...........
have learned during the course." With the onset of the Covid-19 pandemic, the Association.......

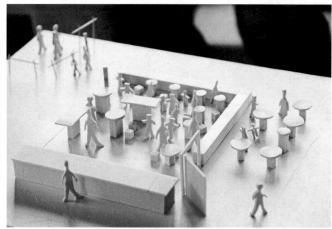

......through language exchange. For C.H., a volunteer at the *Sprachcafé* in Basel,
......foreign workers, expatriates and asylum seekers." The Association's website states:
different backgrounds as possible. Everyone is welcome at the *Sprachcafé* meetings...
...German can come into contact with people from the neighbourhood and practice what they
......created the hashtag *#zusammenonline*. The "social get-togethers" are now held via Zoom.

45 Campus

Marc Zehntner
Weil am Rhein
CH–DE–FR
47°35′42″N 7°36′40″E
147 km²

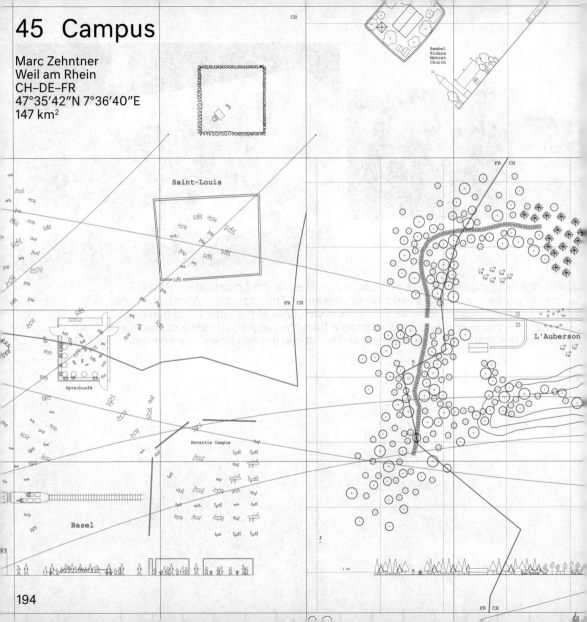

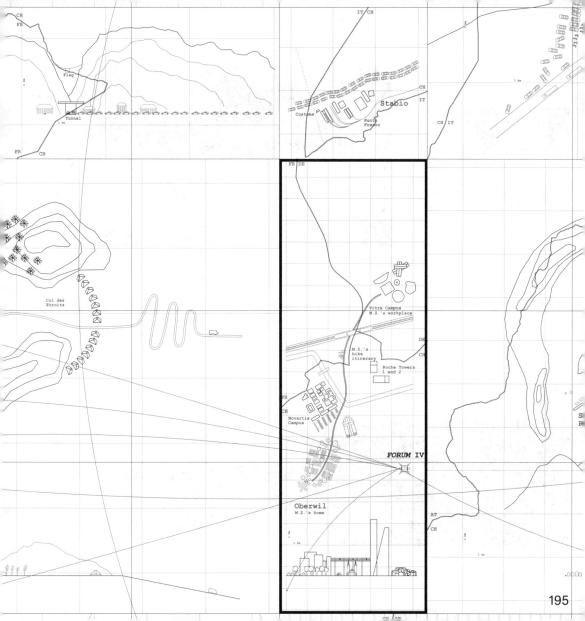

CH
FR

Flag

Tunnel
1 km

FR
CH

IT CH

CH
Customs Stabio IT
Punto
Franco CH IT

1 km

FR DE

Vitra Campus
M.Z.'s workplace

Col des
Etroits

DE
CH

M.Z.'s
bike
itinerary

Roche Towers
1 and 2

FR
CH

Novartis
Campus

FORUM IV

Oberwil
M.Z.'s home

AT
CH

1 km

195

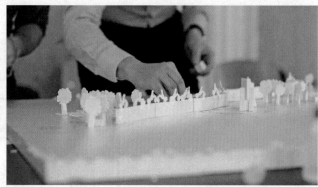

To get to work from his home by bike, M.Z. has to travel through three countries, pharmaceutical and museum campuses. Celebrity architects.............

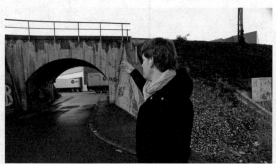

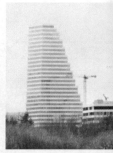

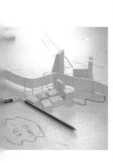

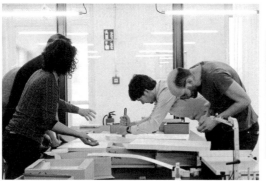

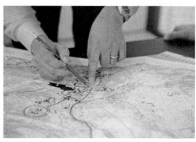

..Along the way, he rides past several facilities as well as designed all the objects that make up those enclosed campuses.

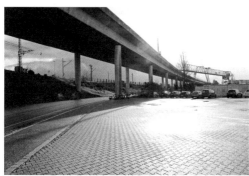

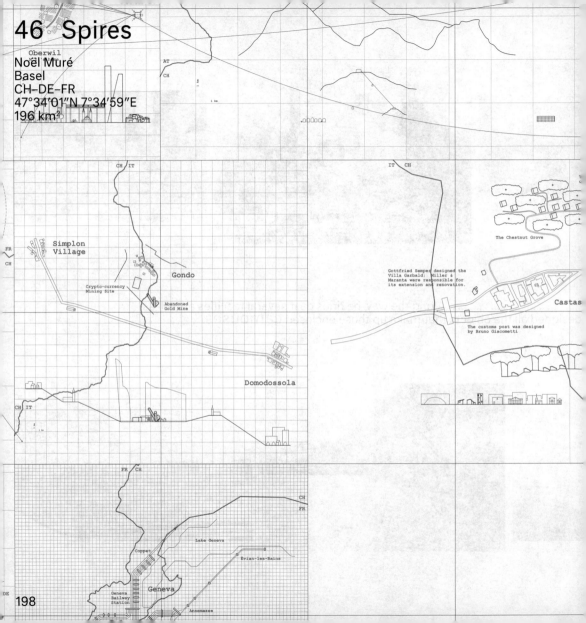

46 Spires

Oberwil
Noël Muré
Basel
CH–DE–FR
47°34'01"N 7°34'59"E
196 km²

AT
CH

CH IT

IT CH

Simplon
Village

Gondo

Crypto-currency
Mining Site

Abandoned
Gold Mine

The Chestnut Grove

Gottfried Semper designed the
Villa Garbald; Miller &
Maranta were responsible for
its extension and renovation.

Castas

The customs post was designed
by Bruno Giacometti

Domodossola

CH IT

FR CH

CH
FR

Lake Geneva

Coppet
Evian-les-Bains

Geneva

Geneva
Railway
Station

Annemasse

DE

FR
CH

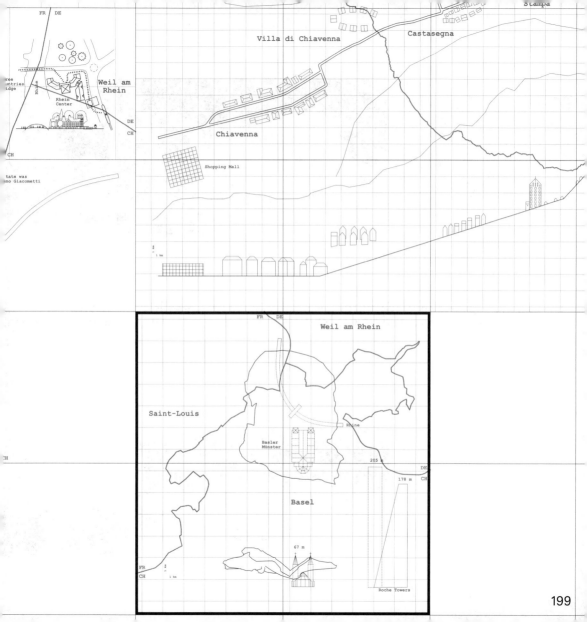

The twin spires of the Basel Münster reach the height of 67 metres. Roche Tower 1 is 178.......
Jacques Gubler, "these twin skyscrapers, the existing one and the one under construction,

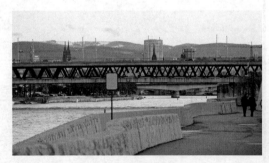

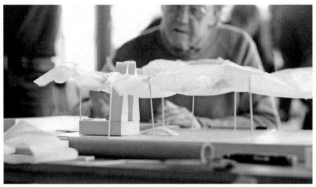
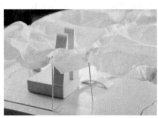

metres tall. Upon completion, Roche Tower 2 will reach the height of 205 metres. For the art historian
...........are akin to Brunelleschi's dome in Florence, which provides shade for the city's residents."

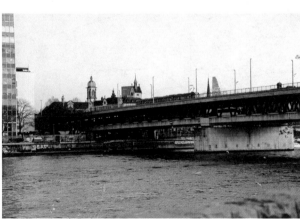

Felicia Lamanuzzi
Stabio
CH–IT
45°51′00″N 8°56′00″E
11,5 km²

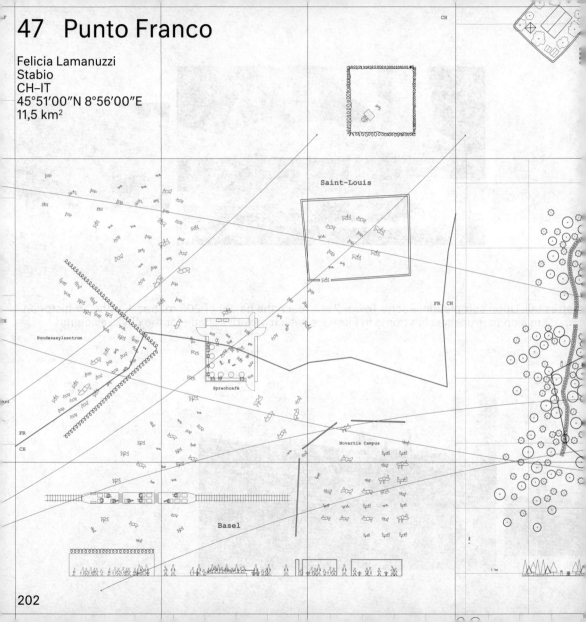

Saint-Louis

FR | CH

Bundesasylzentrum

Sprachcafé

Novartis Campus

FR
CH

Basel

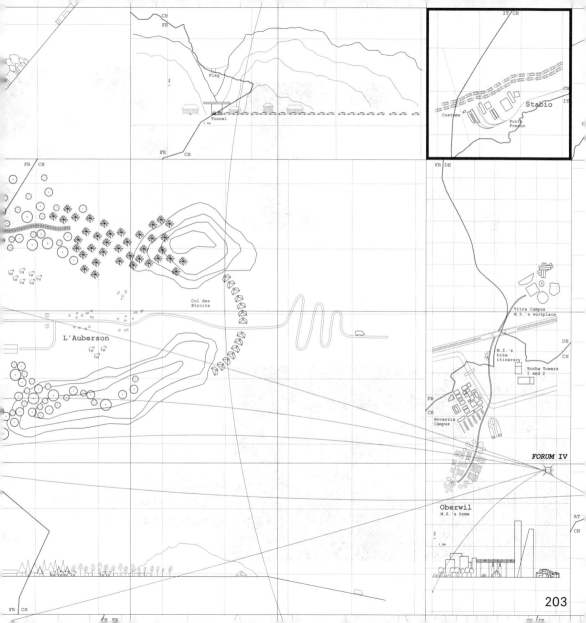

CH
FR

Flag

Tunnel
1 km

FR
CH

IT/CH

Stabio

Customs

Punto
Franco

CH
IT

FR/DE

FR/CH

FR/DE

Col des
Etroits

L'Auberson

Vitra Campus
M.Z.'s workplace

DE
CH

M.Z.'s
bike
itinerary

Roche Towers
1 and 2

FR
CH

Novartis
Campus

FORUM IV

Oberwil
M.Z.'s home

AT
CH

1 km

FR
CH

203

Located at the southern tip of Switzerland, a logistics platform specializes in the road and rail
of Switzerland. In order to reduce border crossing times, a customs office has been set up....
deposited there without being subject to customs duties. *Punto Franco* is part of the..
Every day, commercial road traffic joins the....

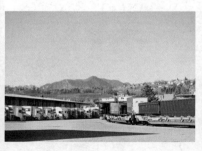

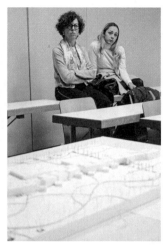

..........transport of **fruit and vegetables from Mediterranean countries** to the whole
...directly on site. Merchandise are stored in the Stabio **free-trade zone** and can also be
.........industrial and logistics development zone along the cantonal road to the border.
...crossborder traffic, generating **go slows**.

48 Casino

–
Campione d'Italia
CH–IT
45°58′15″N 8°58′15″E
2.6 km²

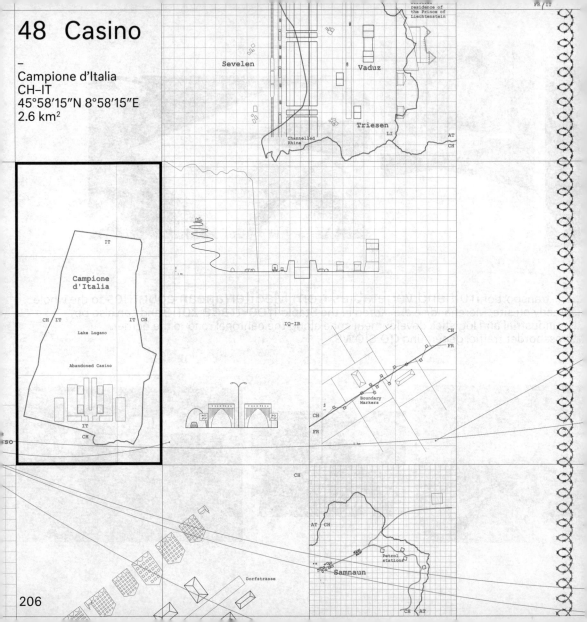

Sevelen

Vaduz

Triesen

residence of
the Prince of
Liechtenstein

Channelled
Rhine

LI

AT
CH

FR/IT

IT

Campione
d'Italia

CH / IT IT CH

Lake Lugano

Abandoned Casino

IT
CH

IQ–IR

CH
FR

Boundary
Markers

CH

FR

CH

AT CH

Petrol
stations

Samnaun

Dorfstrasse

CH AT

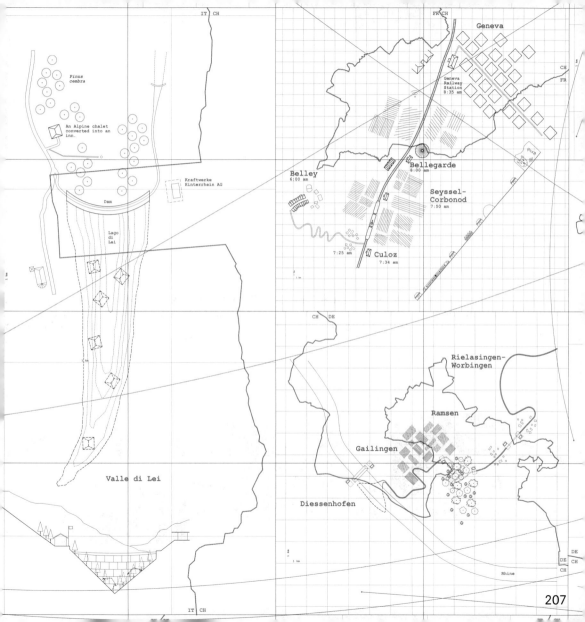

Pinus cembra

An Alpine chalet converted into an inn.

Kraftwerke Hinterrhein AG

Dam

Lago di Lei

Valle di Lei

IT CH

FR CH

Geneva

Geneva Railway Station 8:35 am

CH FR

Belley 6:00 am

Bellegarde 8:00 am

Seyssel-Corbonod 7:50 am

7:25 am

Culoz 7:34 am

CH DE

Rielasingen-Worbingen

Ramsen

Gailingen

Diessenhofen

Rhine

DE CH

DE CH

IT CH

Campione d'Italia is an Italian enclave on the shores of Lake Lugano in..............
with slot machines as its main source of income. After being declared bankrupt in 2018, the............
The architect who designed this vast "white elephant" was then to declare in the
(Now, I believe it's up to the..............

Switzerland. Until recently, the commune was home to Europe's largest casino,
...gambling establishment closed its doors for good. Ever since, the building has been abandoned.
.Corriere di Como: "Ora, credo spetti alla cittadinanza interrogarsi sul suo destino."
......residents to question its future).

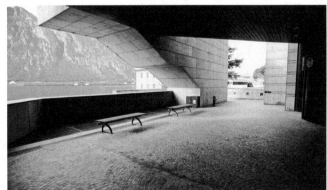

49 Corso

Gianfranco Feliciani
Chiasso-Ponte Chiasso
CH–IT
45°50′05″N 9°01′55″E
1,6 km²

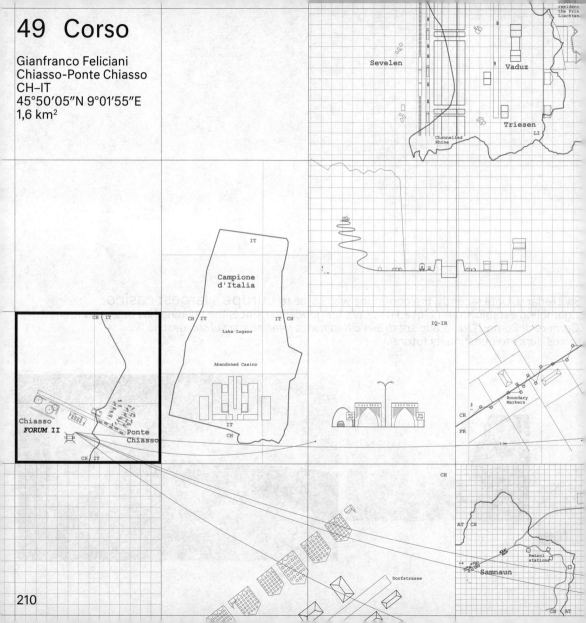

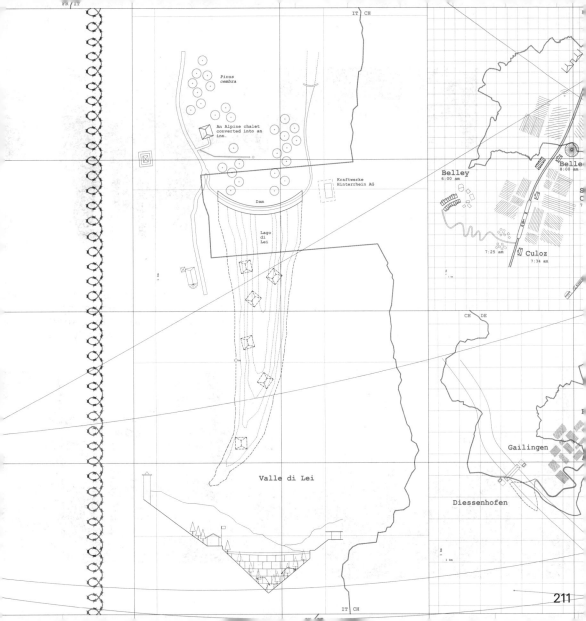

IT CH

Pinus
cembra

An Alpine chalet
converted into an
inn.

Kraftwerke
Hinterrhein AG

Dam

Lago
di
Lei

Valle di Lei

IT CH

IT CH

Belley
6:00 am

Belle
8:00 am

S
C
7

Culoz
7:34 am

7:25 am

CH DE

Gailingen

Diessenhofen

1 km

211

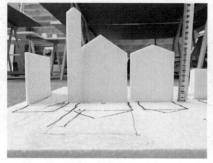

Trucks pass through the **commercial customs**, bypassing the agglomeration formed by...
the town centre. On one side, a pedestrian walkway, recently renovated with red paving-stones....
has again become a two-way street with **illegal parking** lots. Road traffic is
that has been turned into a car park, passers-by jostle noisily, quickly.....................

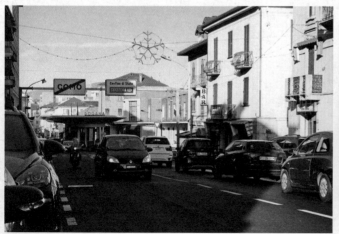
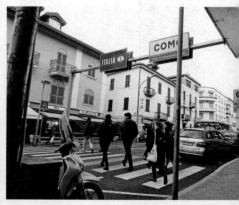

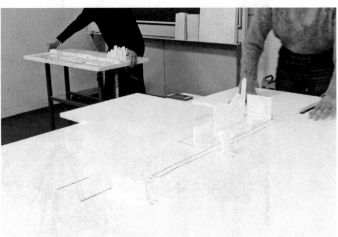

.the two adjoining towns. The **small-scale customs** post divides the street that traverses
....................Cars have vanished and there are very few people. On the other, the *corso* (promenade)
.heavy, and the narrow pavements are crowded. In front of a **public square**
.....gulping down a coffee before heading off to work on the far side of the border.

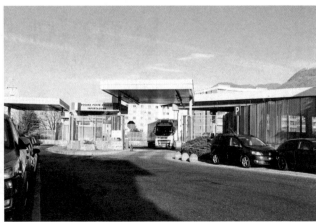

The models made in situ by local residents are precisely measured and drawn.
From these surveys, combining the real territory and the imaginary of those living there,
a large-scale collective model is then built.

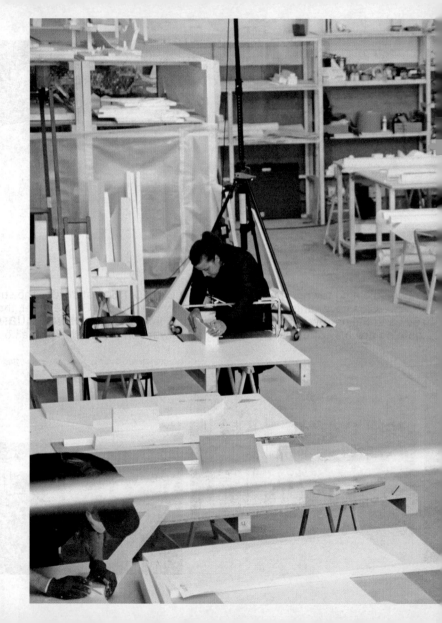

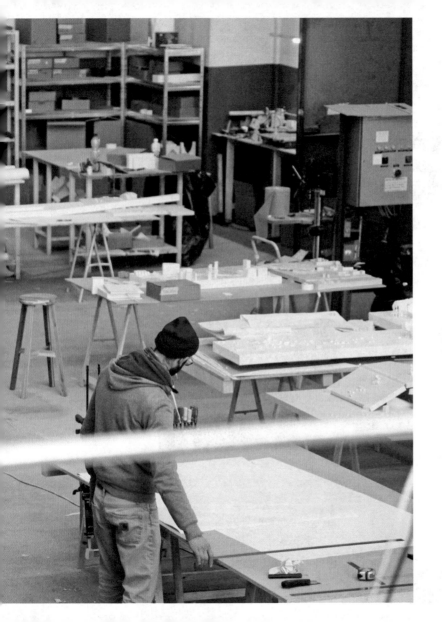

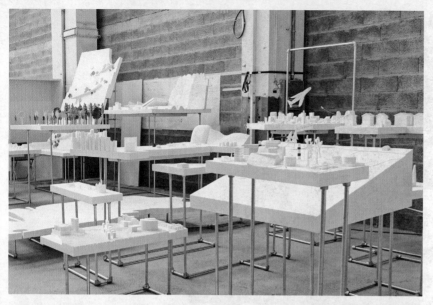

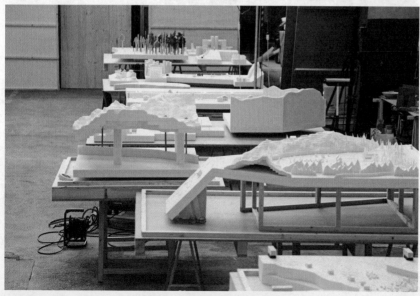

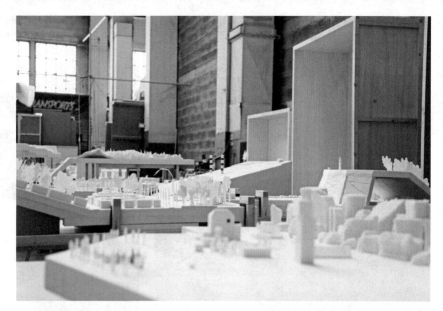

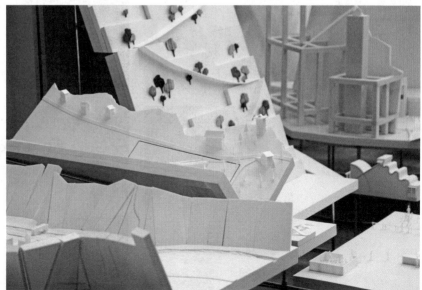

2 ↑

3 ↑

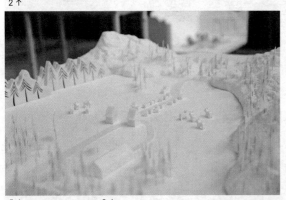

5 ↑ 8 ↓

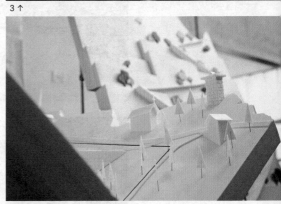

9 ↑ 9 ↓

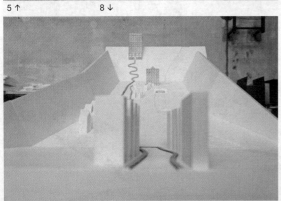

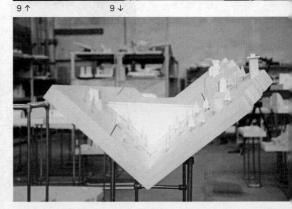

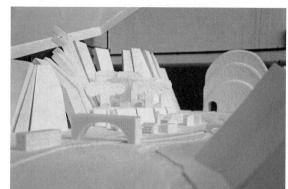

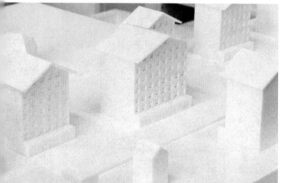

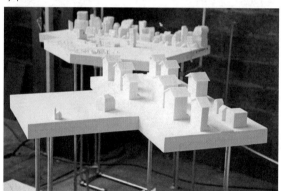

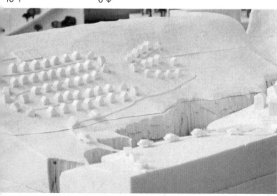

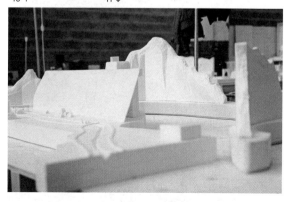

13 ↑

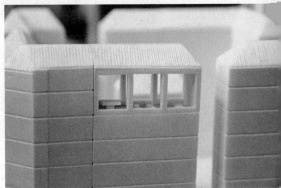

14 ↑

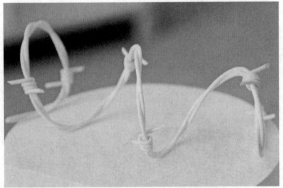

17 ↑ 23 ↓

24 ↑ 24 ↓

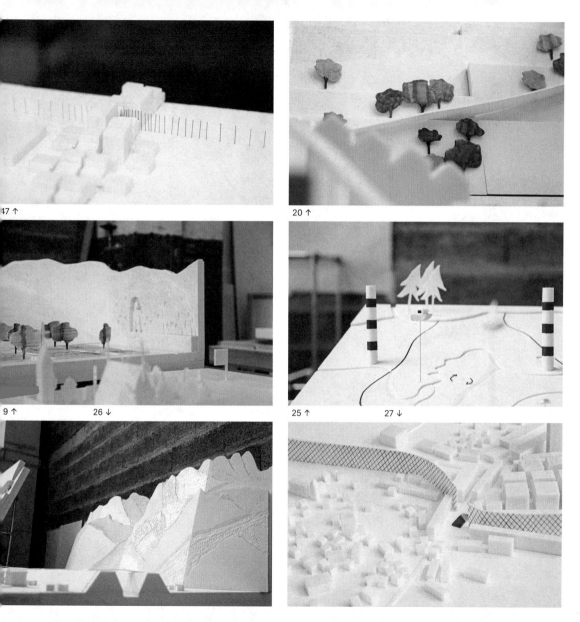

47 ↑

20 ↑

9 ↑ 26 ↓

25 ↑ 27 ↓

28 ↑

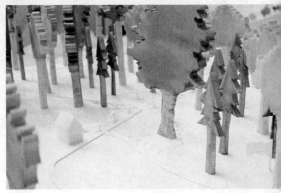

29 ↑

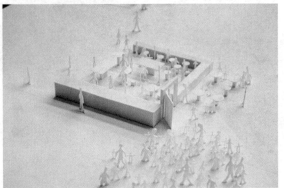

44 ↑ 41 ↓

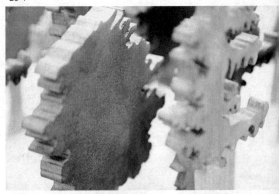

29 ↑ 42 ↓

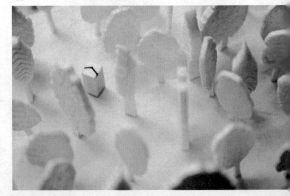

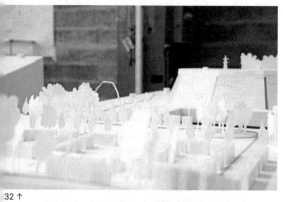

32 ↑

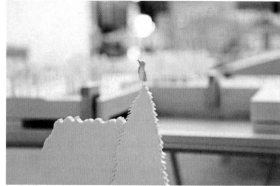

36 ↑

44 ↑ 45 ↓

30 ↑ 46 ↓

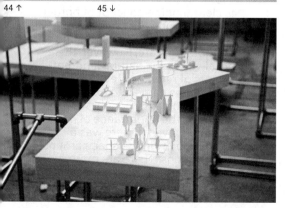

Marc Augé,
Anthropologist

MAy For the anthropologist, the border is indispensable. Without borders, there would be no such thing as an ethnological journey.

MAu Indeed, ethnologists are adepts of borders. Even if borders don't always exist in a material sense, ethnologists nonetheless experience them through contact, through the fact of being elsewhere, amongst a different population. I think that a good ethnology should culminate with an anthropology; that is to say, a reflection on humankind and not solely focused on culture. The anthropologist re-interprets borders and employs them in order to try to think about humanity.

MAy Is this the first time you've been interviewed about the concept of border?

MAu Yes.

MAy You have, however, experienced it and thought about it considerably. How would you define a border?

MAu A border is a significant identification mark that concretely underlines the need for a passage, or a crossing. I think the word "border" has often been associated with the idea of a barrier. It is, however, primarily a device that makes it possible to shift from one conception of things to another. We can moreover employ the term "border" in different senses and not exclusively in the spatial sense. Invariably, there's the idea of a symbolic change.

The border can have a disconcerting aspect. The crossing, the passage from one cultural universe to another is at times perceived as difficult. With that said, the fact that people are positioned on one or the other side of a given border does not necessarily entail they differ from one another. We forget that what underpins the concept of border often bears witness to continuity and homogeneity. The question then becomes: what exactly is meant by this idea of a border and what does it imply? Obviously, if we think of the border as a barrier leading to clear-cut antagonisms, we complicate matters. Perhaps, the border is a subtler reality than we imagine.

MAy The emergence of national borders is often linked to the formation of nation-states. This was the conception that prevailed in the "modern" West. Have there been others?

MAu It is clear that the concept of border was built around the principle of difference between one state and a neighbouring state. However, there have always been natural landmarks or points of reference, even before nation-states came into existence. We have constantly sought to emphasize the importance of differences, even if there was a certain mobility in the space around border regions. There are more mobile aspects to human existence that have impacted, and continue

These dialogues form part of a series of discussions conducted in parallel with the on-site work with politicians, urban planner architects, surveyors, engineers and researchers in the social and human sciences.

doing so, a difference that is claimed in space. This difference can either be implemented or denied.

VL A border can either be affirmed or, conversely, rejected. Oddly enough, nowadays, these two opposing tendencies coexist and are becoming more extreme.

MAu In nationalist discourses, the world consists of barriers all while borders are reinforced. They are deemed a definitive form of self-defence. If somebody crosses them, they are committing a form of aggression! It's a rhetoric of which we're hearing a lot of at present. I believe that such nationalist attitudes touch upon concerns related to humanity in its symbolism and ideologies. There are, however, population flows, migrations, for example, which disapprove of this line of thought. Another illustration would be how those religions, which are driven by the desire to conquer, are dismissive of borders. Hence, these religions can be seen as aggressive and threatening.

VL Together with the forms of withdrawal into nationalist ideologies you mention, there's also a kind of negation of borders that arises from the belief in a world without borders, a world at once continuous and globalized.

MAu Globalization was invented by the capitalist system. This system is based upon the control of production forces; it positions the different nations in a market which is the ultimate reality. The concept of the market refutes that of borders. Today, we can witness a considerable tension between the propensity for empires to dominate the world and global marketplace forces that claim to allow the consolidation of an already existing hierarchy.

Hence, unquestionably, the resistance and the sometimes aggressive aspect of other countries or social groups that want to exit globalization, given how it validates domination by certain classes. From this standpoint, it is interesting to observe how those very-same countries that play an active role in spreading religion worldwide are often also those that aspire to control the flow of goods. They do not want to be simply the capitalist system's plaything.

VL In contrast to the radicality of these two postures, one often comes across a certain subtlety in how the border is defined and articulated by those living in border areas, even if not explicitly so. There are always uncertainties, a desire not to be overly assertive, to leave room for possibilities. This complexity in relationships is characteristic of these spaces. As architects, this is of particular interest to us.

MAu Architecture is directly involved. It can underline or blur the border. Yet, borders never disappear; they are redrawn.

MAy In order to trace and thus represent the border as a threshold, or as a place of passage rather than as a barrier, perhaps we should rethink

this space in terms of its margins, its shorelines, its edge?

MAu The question of a shoreline really does play a complex role in defining the concept of border. Islands, general speaking, represent clear-cut borders a priori. One might ask the question, however, of whether Brexit is related to Great Britain's sense of insularity. Does the fact that it is an island-nation really play a role in its demand for taking back its independence? Or, are the internal tensions and divisions all the greater in a group defined as homogeneous, due to the fact that it is an island? Great Britain would unquestionably find it problematic to define itself in relation to the demands for autonomy pursued by Scotland, Northern Ireland, and Wales, entities with which it maintains complex relations. I think this amply illustrates the relativity and the robustness of the idea of a border.

VL You depict borders as places of contradiction.

MAu Borders are marked by the people on either side of them. Basically, they not only carry their inherent contra-dictions, but also the promise of something else. Borders help us to understand useful differences, yet differences that need to be put into perspective, for they also happen to be zones where humanity reveals itself through its attempts at universality. A universal world is not necessarily a world of uniformity, but rather a world of passage, where one form can call forth another.

VL Worlds of passage and otherness, places along the border resemble an environment of relationships; they never resemble a uniform space. To shift the way we look at these border areas would entail rethinking what is on the fringes, on the shore-line, just as with the beginning of something, on the outskirts of a place.

MAu Outskirts, as a renewed definition of the border: it is interesting that the term "out-skirt" originally comes from the spatial arts to which architecture belongs. Architecture gives shape to time. It transcends local realities, for it represents a more universal objective. If you're interested in these border zones, it is indeed to affirm something that transcends them. There are multiple links between anthropology and architecture: the twofold idea of experiencing differences and of recognizing generic humanity are common to both endeavours.

Anne-Laure Amilhat Szary, Geographer

MAy You are among those who has contributed to raising the profile of what they refer to, in the English-speaking sphere, as "border studies." Some twenty-five years ago, you started working on the theme of borders in Latin America.

ALAS I started to become interested in the question during the 1990s, while I was working on a thesis on economic

geography in Chile. At the time I was working in the Atacama region, located in the north of Chile, a region that borders on Peru, Bolivia, and Argentina. It is a vast territory with multiple borders, but sparsely populated. Although the border between Chile and Bolivia was supposedly closed on account of the lack of diplomatic relations between both nations, I nonetheless saw roads being constructed over a few years and many people crossing the border. It struck to me that those who talked most about the border were not the ones using it on a daily basis. That is what led me to focus on cross-border issues in Latin America. At a later stage, this also drove me to question the border between the United States and Mexico. While much had already been written about this "border of all borders," I was to encounter artists who approached this space in a unique way, both through their aesthetic practices and their conceptual contribution. That experience opened up a rather extraordinary perspective for thinking about and understanding the reality(ies) of borders based on the artistic output I saw springing up there. I observed that the more the world was to abound in walls, the more borders seemed to encourage artistic creation in-situ. After studying these artistic interventions on and along the borders, I took the plunge and became involved in experimental geography, an approach that consists of a methodological renewal that affords pride of place to the researcher's subjective dimension in the production of knowledge.

MAy Ultimately, doesn't the definition of the border, such as we know it today, only date back to the 17th century?

ALAS The matter is slightly more complicated. It is commonly accepted that the idea of a border as a corollary to the concept of territorial sovereignty was invented in 1648, at the ratification of the Peace of Westphalia. Until that juncture, any political construct was based upon a relationships focused on an allegiance between individuals. And yet, the actual implementation of borders, with the help of armies to secure them, identification markers to demarcate them and so forth, only goes back to the end of the 19th and the early years of the 20th century.

MAy The concept of a border, however, has been around for much longer.

ALAS Yes, you are right. That idea that borders originated during the 17th century is highly questionable. There are stelae, those upright stone slabs that date from the Neolithic era and they already indicated the boundaries between kingdoms. In the Near and Middle East, as well as in Central Asia, archaeologists have discovered walls that constituted, in the eyes of many, boundaries, notably between nomadic and sedentary populations.

MAy In the Western mental universe, the Roman Empire's *Limes* seem to be the ancestor of the concept of the border.

ALAS In the Western world, the idea of a border was born with the myth of the founding of the city of Rome.

The furrow Romulus traced with a plow separated two areas that were not yet differentiated, but which were about to become so. When his twin-brother Remus stepped over it, he provoked Romulus' fury. This dispute between them was to culminate in a fratricidal deed. Indeed, this founding myth of Rome tells us that the border is at once a representation and an enactment, with one not functioning without the other. And that the border is inherently the site of symbolic violence.

VL Do you mean that the border is a spatial concept in which the material and the ideal go hand in hand?

ALAS It is in this very interaction between representation and enactment that the concept of border plays out. They are completely correlated. I disagree, for instance, with the idea that the border is a device stemming exclusively from international law, dictated from above. If there were no smugglers and customs officials to underpin the border, it would not exist. The norm only exists when it is put to the test by transgression. To get back to your initial question about the origin of borders, I think we can distinguish three very ancient sources thereof. First, there are the boundaries between nomadic and sedentary peoples. Second, as soon as a segment of the population settles down somewhere, cities begin to emerge as places of wealth. Potentially vulnerable, they had to be defended by ramparts. Lastly, the third origin is that notion of private property. The seventeenth and eighteenth centuries, a period

in which borders were being erected throughout Europe, corresponded to the end of the clearing of forests and "enclosures," and consequently to the establishment of exclusive individual property. So, I would venture to say that borders have always existed throughout the ages. Those borders found elsewhere on Earth do not necessarily function on the model of territorial exclusivity such as conceived of in Western thought.

MAy On that topic, are there other definitions of the concept of border in other mental universes outside the Western system of beliefs?

ALAS It was the West that invented this idea of sovereignty attributable to a single power and hence of territorial exclusivity. In other mental universes, as for example on the Pacific islands, there are maps that represent the possibilities of interconnecting spaces and people rather than separating them. A space for negotiation that enables one to define oneself in relation to the other. There are of course differentiated cultural and political universes, but it is more a case of a mosaic of interconnected spaces. What interests those who live in these places is to have both individualised nuclei of settlements for groups and also spaces that are, anthropologically speaking, interethnic. Everywhere, the border is a space where one differentiates oneself from the other, while at the same time one confronts oneself. It's a space for negotiation that enables one to define oneself in relation to the other.

MAy In stating that the border is a space for negotiation, we immediately think of negotiations between states. Weren't a significant portion of the borders throughout Europe that we know today drawn up during negotiations for the Treaty of Versailles in 1919?

ALAS Modern borders began to be invented in the 17th century, and subsequently the European model was exported to the rest of the world through colonisation. The Berlin Conference in 1885 represented another defining moment for borders when Africa was being divided up. The end of the First World War was another critical juncture with the promulgation of the right of peoples to self-determination… but also the pursuit of colonisation in the Middle East, for example, and in particular the drawing of the well-known Sykes-Picot line. Those individuals who ratified those treaties are long since dead, and yet, on the ground, they still have to negotiate with the reality that ensued from those flawed agreements. Although the United Nations would like to have us believe that those maps represent a permanent arrangement, in reality, they are constantly being re-negotiated. From the time the United Nations was founded (1945) until the present day, borders have been constantly created. Initially, U.N, had some fifty-plus member states; today there are almost two hundred. All this in the name of a supposedly stable system of international law… Hence, the unwavering nature and linear stability of borders are highly relative concepts. It is interesting to note that borders link up a whole series of decision-making and actor scales that are not necessarily interlinked, traditionally. Those ambassadors gathered at the conference in Osnabrück to ratify the Peace of Westphalia may have well thought that a particular mountain or a river could make a suitable border, but they never had set foot in that area. Those living in close proximity to a river know perfectly well that it is a meeting place around a common natural resource and not a place of division. Similarly, in mountainous regions, the grazing lands at high altitudes are areas for sharing and for pooling resources.

MAy And yet, this idea of a natural border seems to persist…

ALAS In the highly self-centred Western world, this idea is strongly anchored, for it is based upon a religious belief system. In the 17th century, those who invented the idea of the border were sovereigns who ruled by divine right. Within this belief system, the earth, mountains and waterways were considered divine creations. To meddle with borders was thus tantamount to calling divine right into question. There is something extremely powerful in this system of representation. There's absolutely no such thing as a natural border, however. A peasant in the Pyrenees was equally as shocked by crossing the border as were the nomads in the desert by those borders determined by the Skyes-Picot Agreement.

MAy The implementation of treaties such as the Sykes-Picot Agreement in 1916

has, at times, given rise to extremely violent consequences, whose impact still has to be reckoned with today, notably throughout the Middle East.

ALAS In Palestine, the much-touted Separation Wall is a highly publicised artefact. Yet, researchers have shown that for the Palestinians, the real borders are the three residential areas and the checkpoints. Ultimately, that wall was mostly meant to cut through and divide Palestinian communities. The intent behind the wall is to get them to let go of their land. It equally enables some radical, ultranationalist Israelis to do things behind that wall that the so-called democratic system would not explicitly provide cover for.

MAy Between Mexico and the United States, the construction of the border wall is equally the manifestation of a very hard material process. In parallel with these walls that are being erected, an intangible world is flourishing. A world of extreme mobility and information technologies. Borders seem to be following two contradictory movements: territorialisation and de-territorialization.

ALAS The border between Mexico and the United States is at once the most tightly sealed and yet the most crossed border in the world. For those thousands of migrant workers, this is a highly integrated region. And yet, for migrants lacking the necessary documentation, it is totally impenetrable. Depending on who you are, where you were born, and how much you have in your wallet, the border is more or less

open. Each border concurrently "deterritorializes" and "reterritorializes" itself. Gilles Deleuze and Félix Guattari effectively explain how the two processes are concomitant within one and the same space. Territorialization, or at least the physical manifestation of borders, not only plays out along the borderline, but also in places away from the borderline as well. The border has been increasingly embedded into people's bodies. We carry it within ourselves.

VL We encountered a border guard who told us about an ongoing project that consists in digitizing customs procedures. Based on camera checks, statistics, and risk analysis, the AFD [the Swiss Federal Customs Administration] aims to reach a 100% success rate with crime control checks. What is particularly disturbing about this project is that the current controls at the customs level will be replaced by a nation-wide surveillance. The border will thus be extended to cover the entire territory.

MAy Paradoxically, the introduction of these kinds of control mechanisms reveals a tightening of border-controls. But national borders as we know them today are the result of nation-states. Do these phenomena perhaps conceals a strong challenge to the concept of the nation-state?

ALAS Since when has the nation-state existed? The answer differs depending on where you are. France has a highly stable idea of its border, built over a protracted time-frame. In Germany

and Italy, on the other hand, it is a fairly recent phenomenon. The upheavals that ensued from German nation-building put Europe at war twice in a row. The nation-state arguably existed in the inter-war period. At the same time, those that most strongly proclaimed its existence were often colonial empires that did not grant full-fledged citizenship to all members of the empire. Immediately after the end of the Second World War, the independence movements throughout the colonies and the construction of the European Union, in turn, severely undermined the whole concept of the nation-state. I think the answer is not political, but rather economic. For a long time, we have been dealing with highly territorialized economies at a state level. Throughout the 1970s, and again from the 1990s on, financial globalization erupted in an extremely violent manner. Ever since that juncture, the idea of economic independence has been strongly challenged. Which leads to the question: are borders undergoing transformation? Yes. Are they vulnerable? Yes. Have they never been stable? It's not obvious.

MAy Today, who benefits from the existence of borders?

ALAS I would pose that question differently: "What interest do we have in maintaining borders? We could all become in favour of "no borders," but at the same time, we still need to define ourselves, to distinguish ourselves from others. Hence, our need for borders. Another advantage is that borders constitute a protective system: they operate according to the two-part security-opportunity structure. We are all, to varying degrees, tempted both by an opening for our opportunities and a need for security.

VL In this respect, borders create differential and hence value.

ALAS We don't discuss it a lot, but borders often operate hand in hand with the capitalist system. They guarantee the value of currencies, the creation of markets. Conversely, they have over and again rendered the labour market more flexible, affording rights to some while taking them away from others, often at the expense of individuals and to the benefit of Capital. Borders are as much an economic project as a political one.

VL Today, the border zones – more so than elsewhere perhaps – are creating spaces where one is singularly confronted with oneself and with others, with the world. At any rate, this is one of our project's key conclusions: perhaps, it is no longer so much in large metropolitan centres that the individual is confronted with globalization, but rather on and along the borders.

ALAS Indeed, borders are places where the process of globalization has been truly exposed. They constitute a particularly favourable setting for observing the phenomena of globalization phenomena in the 21th century.

Hitherto, as the state's prerogative, the border constituted an institutional filter that protected the individual from the outside world. Today, however, it effectively places individuals directly in the grips of globalisation as well as the violence it perpetrates.

MAy If we take the time to observe these places, to find meaning in them, to name them, these places may well contain some unexpected potential. They wouldn't be relegated from the territory, but instead considered as a part of it.

Matthieu Calame, Agricultural Engineer

MA In your recent writings, you've argued that Europe ought to follow the Swiss federalist model. In light of this idea of European federalism championed by Denis de Rougemont in the immediate post-war years, how can we rethink borders both at a State and a European level?

MC The specificity of Switzerland is that it is a non-nation state. It clearly defined a territorial space at a given point in time, but this space was primarily a political alliance. At a time that the ideology of nation states was taking root across Europe, with all the ensuing havoc amongst its ethnically and religiously highly-mixed populations, Switzerland did not opt for cultural homogenization. Instead, it went about developing a completely paradoxical model of a thoroughly multicultural nation.

VL It was at that juncture, circa the 17th century, that the concept of the border as the delimitation of a space under the authority of a single administrative power emerged.

MC Yes, the endeavours involved in homogenizing a single cultural space go hand in hand with the efforts required to defend its borders.

MAy Basically, today, aren't we still trapped in an artificial determinism of a direct correspondence between a territory and a given power?

MC Until the Middle Ages, there was no such idea of territorial unity. It all began with what historians refer to as the Westphalian Order, devised in the 17th century, that people wanted to create relatively homogeneous entities within defined borders. And, indeed, we are still grappling with that particular rationale. Yet, as soon as borders come down, it becomes difficult for the central administrative power to consider itself as the sole representative of the community in a given territory in which it is located. Whereas the nation-state seeks to merge the act of governing with that of administering the country, federalism, in a way, responds to the need to collectively agree on a common direction – that which Alexis de Tocqueville called "common government."

VL Europe seems to have reached a political impasse: we can observe this all along its borders.

MC Everyone realizes that Europe has reached an impasse that is potentially

fatal. Any political construction proves to be artificial. And the border is one such artificial construction. It depends directly on the political order that put it in place. The current European political order is faltering, however. In my view, Europe has but two options available to it: either it disintegrates, or it makes the shift toward federalism. This federalist solution strikes me as the only viable way that will enable Europe to take the necessary decisions to confront significant problems.

MAy Which specific problems are you referring to?

MC We could observe this during the recent migration crisis. This resulted in some very surprising border closures. Another case in point is the coronavirus pandemic we are currently grappling with: governments have been discouraging their citizens from leaving the national territory. These constitute administrative acts that involve restricting the population's freedom of movement. The border is at once a protective device and a means of restraining a given population under the governments' own jurisdiction and control.

MAy In your opinion, what has been the pandemic's impact on borders?

MC The pandemic has demonstrated a strong return to borders in the imagination, accompanied by the utterly futile hope that we will once again be able to compartmentalize. What's at stake here are the dynamics of living elements within the ecosystem. Whenever a virus hosted in an animal species crosses over to man, it is said to have crossed a border. The great dream of GMOs, for instance, has been to cross borders. In the real world, however, there are borders and things can go wrong whenever they are crossed. The administrative borders which we've inherited sometimes have little to do with other borders. I would almost speak of a clash of borders. Different types of compartmentalization clash. Biological borders collide with administrative borders and come into conflict with them.

VL The border seems to function as a dual mechanism, at once exclusive and inclusive.

MC Yes, the border does not only operate with regard to the exterior. It also holds back, in the interior. Hence, it devises an entity, an identity. We use the border to reassert our sense of belonging. It remains closely linked to the concept of the territorial principle. Being born in a given territory surrounded by borders entitles us to the right to citizenship. Democracies are thus contingent upon their borders: within these defined limits we become a member of this community and we have the right to participate in the government of this territory. So, the idea of political rights is closely associated with that of the border. This is not the case with monarchies, for they are permanently driven by a rationale to expand their borders. They want to keep them porous. And yet, in

democratic cultures, enlarging the territorial space would be tantamount to sharing power, to a feeling of being weakened: moreover, this is one of the major qualms the Swiss have about joining the European Union.

MAy Doesn't the size of the territorial unit, as defined by a border, impact the perception one can have of it?

MC The border does not have the same meaning when you are a small or a large country. In Switzerland, the border administration supervises a much larger proportion of the national territory than in the United States, for example. The question of the nature of the border thus varies according to the size of the territorial whole it encloses. The smaller the country, the more enormous the significance its border assumes. One could consider Switzerland as an immense border surrounded by Europe.

MAy A "roundabout."

MC That term is apt. In Switzerland, there's a significant flow of goods and people. From a historical perspective, Switzerland built itself around its ability to control the mountain passes. And this activity persists. If there is something characteristic about this country, it is not so much the border itself, but rather its control of transalpine traffic. Rather than its borders, it is this redistribution of responsibilities across the cantons that has made Switzerland the country that it is. This is the polar opposite to the centralized state model that constantly absorbs its periphery.

MAy It is often the case that those who reject borders are the very people who wish to uphold them. This mechanism follows two parallel reactions: it re-territorializes and de-territorializes simultaneously.

MC It is understandable that these two reactions are concomitant. In order to expand their empire, the Romans concurrently built military routes to transport their legions and the limes (from the Latin for "road" or "limit"), the fortifications that fiercely defended the Roman empire's borders. Today, those same people who are afraid of losing their identity are nonetheless heading off to the far end of the planet on sightseeing-trips. It strikes us as contradictory, yet the more porous one renders the border areas, the more one increases movement and the greater the urge one feels to control that flow. Had such flows not existed in the first instance, there would have been no need to control them.

MAy Thinking of the concept of border in terms of the flow of goods and people strongly questions its territorial determinism. For those fields of study concerned with spatial planning, the rupture is radical. How do you see it?

MC The process of architectural modernity is to enable mobility, to disconnect from the locale. The modern city is a prime example of one that is in a state of flux.

VL Are flows constitutive of contemporary territory, much more so than its limits?

MC We could classify the territorial systems according to the degree of porosity of their borders. On one hand, there are completely closed systems. A seed would be a case in point. Its internal degradation process is very slow. The seed is an organ of resistance. On the other, there is the conduit. Here, it's a case of pure flow. At either extreme, the metabolic rate is virtually zero. Basically, the question is that of the correlation between living organisms and ecosystems. If we target the optimum metabolic rate, it won't happen either through a total opening up or an outright closure of borders.

MAy Do we always need to seek out an intermediate state?

MC Yes, the whole debate revolves round this point. There's not a bipolar division between those who want to close borders and those who want to open them. There's no sense in wanting to shut them down completely, just as there is no sense in wanting to do away with them. As soon as we open them, however, the question of how to regulate them arises.

VL We could look at matters differently. It is also thanks to the very existence of this border, which creates a differential between two locations, that trade occurs. A flow of people and goods is precisely what ensues from divergences in currencies, administrative systems, and cultures.

MAy Am I right in saying the federalism you have been advocating aims precisely to lessen this border effect?

MC If we were to apply the federalist system to Europe as a whole, it would necessarily have the effect of reducing borders between the old nation-states, all while generating a central government. Federalism should be considered as a compromise between centralization and decentralization, a political organization whose goal is co-existence amongst intertwined territories. Not combined, but rather intertwined. Let's take the climate issue. I don't believe in the idea of an ultra-centralized super state that singlehandedly identifies targets and the means with which to achieve them. In a federalist system, the central government would set such targets and the individual states would have administrative freedom to achieve them with whatever means they wished.

VL So, are we entering a post-border era?

MC Yes, we're no longer operating within the Westphalian framework of the nation-state with a defined territory and borders. The United States is already functioning in an imperial post-border logic. As organizers of the "world system," it is now a matter of knowing how to exercise its imperium by projecting its military as well as monetary power far beyond its national borders. By creating the concept of the U.S. Person, for instance, the United States administration thus determined that any corporation worldwide that uses the U.S. dollar is subject to United States Federal law.

This represents a critical rupture: effectively, the United States projects its laws beyond its borders by dint of the usage of its currency.

MAy So, in this post-border era, we are left with the choice between the "Swiss-style" federalist approach or the American imperialist system. In either scenario, how will the current borders that have been inherited from the nation-states evolve? Will they ultimately disappear?

MC The current borders remain the foundation of international law. The idea of a world without borders is highly dangerous. In their absence, everyone would have the right to interfere with everybody else's country. The imperial system is an excellent one in that it doesn't have borders. Notwithstanding, for small nation states, the recognition of their borders does have a protective aspect. In 1815, at the Congress of Vienna, Switzerland's recognition within its borders by other European countries ensured its survival. So, before we scrap the current borders, we first need to envisage what a world without nation-states would resemble. Rethinking international law in the absence of borders is far from obvious.

VL Today, even within the same territory, there's quite a multiplication and superposition of borders...

MC In Switzerland, we have an array of internal legal, administrative, linguistic borders... We are indeed entering a multi-frontiered world.

The idea of an absolute space that corresponds to an individual entity's every single reality, whether political, economic, administrative or otherwise, is long past. This is where nation-states, which considered themselves perfectly unitary entities within the confines of their borders, have failed. And yet, I do believe that the borders derived from these nation-states can help us enjoy a well-accepted intercultural life that is not communitarianism.

VL In Switzerland, sometimes internal borders are more significant than national or external borders. We come back to the question of scale: beyond a certain size, the concept of borders seems to be slowly disintegrating...

MC From a hydrological perspective, Switzerland constitutes the water tower of Europe. If we limit our reference to the continent as a whole, Switzerland would then be considered as a vital space for all European countries. If, however, we were to take a municipality as the basic whole, the superimposition of the different administrative, economic, and legal borders would certainly expose regulatory spaces with variable geometries, and in all likelihood finer ones.

VL What do you think is the most meaningful scale today?

MC There are those, given they possess the wherewithal, who can easily project themselves into a world space

without borders. They represent a minority. And then there's the majority of people who are condemned to remain wedded to the destiny of a given territorial space, for they cannot afford to leave it. Depending on who you are, your sentiment, or resentment as the case may be, toward borders will vary considerably. I think we can imagine a sociological unit that corresponds to the space required for an average family to bring up a child as far as adulthood. This would give you the fundamental unit, the living space actually experienced by 90% of the population. Beyond that, you cannot claim genuine autonomy. The border is primarily a phenomenon linked to our lifestyles. Animals urinate around or on tree trunks in order to stake out territory. The territory they stake out is thus linked to a particular behavioural trait, to their way of being. The same could be said of human beings.

VL More than elsewhere, perhaps, those living on the border are confronted with the full force of globalization... The border is a place where the individual and the world collide, sometimes violently.

MC It is indeed likely that borders are places where globalization is experienced most intensely, and at times it involves pain for those who experience it.

VL More than elsewhere, people living on the border seem left to their own devices. They lack a collective narrative as we might find in urban areas. We refer to an urban or metropolitan culture, yet never to a border culture. By definition, however, a border is a space for negotiation, for passage, and thus conducive to the collective imagination. We often notice a form of resistance, of transgression in people who live there.

MC Yes, that is the smuggler's and the trafficker's culture. There's effectively no established identity for those who live on the border. They suffer from invisibility, but yet have significant cultural weight.

VL The environmental arts and sciences are scarcely concerned with these border spaces, except to consider them as non-places of scant interest.

MC The migratory, climatic, epidemiological crises that we are currently experiencing, however, point to something else...

Postface
Madeleine Schuppli

Head of Visual Arts, Pro Helvetia
Commissioner Swiss Pavilion

In summer 2018, the Swiss Arts Council Pro Helvetia decided to select the official Swiss contribution to the 17th International Architecture Exhibition of the Venice Biennale via an "open call." As was the case the previous two years, the call for entries met with broad interest in the Swiss architectural scene, with a total of 51 project files submitted to the five-member jury appointed by Pro Helvetia. The projects for the Swiss Pavilion proved to be a revealing reflection of urgent issues driving the Swiss architectural world. After a presentation of the seven projects selected in a first round of judging, five projects were invited for a second round and further development of their ideas. From this shortlist, the project "oræ– Experiences on the Border" finally prevailed as the winner. The team with Mounir Ayoub, Vanessa Lacaille, Fabrice Aragno and Pierre Szczepski was subsequently nominated by Pro Helvetia in January 2019 for participation in the Architecture Biennale, which at the time was still planned for 2020. The jury viewed the proposed examination of the little-explored Swiss border areas and the living environments of their inhabitants as highly topical and promising with regard to a multimedia exhibition in the Swiss Pavilion: "The project makes it possible to initiate a discussion on the topical issues of the perception of national borders while drawing a tangible, poetic and nuanced portrait of the Swiss border and its cultural plurality." Given the presentation at an architecture exhibition, the transdisciplinary approach also appeared to be a productive setting: the collaborative team included not only the young architects Vanessa Lacaille and Mounir Ayoub from the Laboratoire d'Architecture in Geneva but also the experienced French-Swiss filmmaker and cinéaste Fabrice Aragno and the French sculptor Pierre Szczepski. Finally, the methodological approach was convincing: the people living close to the Swiss border would have an opportunity to participate in the development of the exhibition for the Swiss Pavilion not only by means of open discussion, but also through the constructed models of their perception of the border landscapes they had provided.

I first met the nominated team at the end of 2019 during their research trip, when they stopped in Basel on their extensive tour of the Swiss border. Together we visited the border area. We walked together along a faceless road in the border triangle between France, Germany and Switzerland, which naturally bears the name *Grenzstrasse* (Border Street). International 40-tonne lorries from all over Europe were parked at the side of the road, while the sirens of the transport ships from the nearby Rhine harbour awakened longings for the sea in the heart of mainland Europe. Seemingly endless goods trains thundered over the neighbouring railway line, as the high-speed express-way resting on mighty concrete pillars roared incessantly. In the midst of it all, seemingly unaffected by the traffic noise, a lorry driver treated himself to a snack while sitting at a camping table despite the sharp December breeze–a breakfast in the no-man's-land between three states that spatial planning has overlooked. A joint sign of the Basel Border Guard Command, the Lörrach Main Customs Office and the Weil am Rhein Border Guard Office stated that pedestrians and cyclists were only allowed to cross the border at this point during the day if they were carrying valid documents, while persons not carrying a visa were prohibited from crossing. Nor is it permitted to carry goods that are subject to duty. Fabrice Aragno's documentary camera was running and Marc Zehntner, our knowledgeable local guide, accompanied us through the faceless area. In the process, the museum director told us about his 22-km commute, which he did almost daily by bicycle and which took him across three national borders to his place of work at the Vitra Museum in Weil am Rhein.

The Geneva-based team's decision to approach their object of study via a multi-part research trip, a kind of border survey, has paid off. During their travels in a lorry converted into a mobile studio, they entered a hitherto little-interpreted territorial dimension and engaged in countless conversations and workshops with border residents, bringing to light a very specific social and cultural structure. Their project and exhibition explore the border landscape and the identity of its inhabitants. They let the people have their say about their self-perception, their needs and views, thus giving concrete form to their living space as a territorial sphere of its own. While certain experiences of this fascinating journey along the Swiss border might well be due to Switzerland's "insular" special situation as a non-EU member state, the insights gained therefrom prove universal in many respects. One of the findings of the journey to the borders is that border territories offer an ideal laboratory in which to observe globalisation phenomena, for they characterise the world of the 21st century. Over the course of the research, it also became clear, as the project title with the Latin word *oræ* suggests, that borders do not have to be the end and the conclusion. Rather, they are, so to speak, the beginning of something– just as the seashore demarcates the land from the water, it also opens the view up to the wide horizon of the sea.

Hashim Sarkis, the director of the 2021 Biennale Architettura, is also pondering the unifying aspect of borders with a view to a vision of the future. The theme of his exhibition in the Central Pavilion and the Arsenale in Venice, "How will we live together?," formulated a few months after the Swiss project was chosen, is divided into five sub-chapters, one of which examines the possibilities of future coexistence "across political borders in order to imagine new geographies of association."

While the Swiss nomination of the project signalled the relevance of the topic, the global crisis triggered by the Covid-19 pandemic in 2020 made it even more explosive. For example, Europe faced the first closure of its national borders since the Second World War! At such a catastrophic moment, the hard-pressed global community acted reflexively within national borders to combat the virus: where yesterday the Swiss southern border between Como and Chiasso was a permeable membrane allowing cross-border traffic to flow unobstructed, and people from Italy and Switzerland to meet daily, virtual Berlin walls sprang up overnight, turning the affected border areas into temporary exclusion zones. The border closure had a very concrete impact on the Geneva-based *oræ* team. From one day to the next, individual employees could no longer get to the Geneva studio where they were working on the landscape models for the Venice exhibition in spring 2020, bringing work almost to a temporary standstill.

The pandemic-related postponement of the Biennale by one year to May 2021 offered an opportunity to further develop and mature the project. Accordingly, the team decided to set off again in March 2021 with a "mobile forum" designed and built in collaboration with the Architecture Department of the Bern University of Applied Sciences. Within this forum, they organised discussion and collective writing workshops with the inhabitants of the border encountered during the first round. By updating their study at five selected locations along the border, they were able to integrate into the project a survey of the impact of the Covid-19 crisis on the population living near the border.

All the previous projects in the Swiss Pavilion at the Venice Biennale were the result of a major joint effort. This is even more true for the project "*oræ* – Experiences on the Border." The collaborative approach chosen by the project team involved over a hundred people in active participation and field research. They are the ones who contributed all the valuable knowledge, ideas and multi-faceted stories of the territory on both sides of the Swiss border. Let us hope that this rich corpus can help society as a whole to gain new insights and a fresh view of the border areas with which we have often been less familiar up to now.

The Covid-19 pandemic forced the Biennale to twice postpone the 17th International Architecture Exhibition, which is finally due to open after a year's delay. It is only thanks to the perseverance and determination of the nominated team with Mounir Ayoub, Vanessa Lacaille, Fabrice Aragno and Pierre Szczepski and their collaborators Noémie Allenbach, Benoît Beurret, Jürg Bührer and Annabelle Voisin that the project could be brought to a successful conclusion despite the most difficult conditions. Our sincere thanks go to all those who supported them in word and deed, and to those whose generous financial support made a project on this scale possible in the first place. It is worth noting that they continued to stand by the team at the time when almost everything had ground to a halt due to the ongoing Covid-19 lockdowns. To all those who have advised and helped them in their endeavour, and to those who through their generous financial support have made such a major achievement possible, a very big thank you. Continuing to support the team was not simply a matter of course at a time Covid-19 was causing a never-ending lockdown and disrupting almost everything. We would like to thank all the supporters who maintained or even increased their support and thus allowed the project to develop during the year in which it was postponed.

We are also particularly pleased that the Bern University of Applied Sciences with its Department of Architecture joined the project as an active partner and assembled the "mobile forum" together with students, giving the up-and-coming generation of architects a taste of "Biennale air." Finally, my thanks go to the Biennale team of Pro Helvetia with project leader Sandi Paucic, project manager Rachele Giudici Legittimo and assistants Martina Lughi and Anita Magni. With great commitment and skill, they accompanied the project throughout every phase and kept it on track.

This publication is produced to accompany the 2021 exhibition for the Swiss Pavilion titled *oræ – Experiences on the Border*, which takes place from 22 May to 21 November, 2021 at the 17th International Architecture Exhibition – La Biennale di Venezia. It is commissioned by the Swiss Arts Council Pro Helvetia.

Authors and Editors
Fabrice Aragno, Mounir Ayoub, Vanessa Lacaille, Pierre Szczepski

Copy-Editing and Proofreading
Barbara Autenrieth, John Barrett, Monica D'Andrea, Jean-Pierre Grenon, Marie-Jeanne Krill

Translations John Barrett

Images Swiss Pavilion's team of the Venice Architecture Biennale

Graphic Design Irma Boom Office (Irma Boom, Jan van der Kleijn)

Lithography, Printing
Zwaan Lenoir, Netherlands

Typeface Neutral

Paper Opakal 60 gsm, Munken Polar 240 gsm, IBO One 60 gsm

Print run 2.500 (English and French)

Lars Müller Publishers is supported by the Swiss Federal Office of Culture with a structural contribution for the years 2021–2024.
Lars Müller Publishers
Zurich, Switzerland
www.lars-mueller-publishers.com

Distributed in North America by ARTBOOK | D.A.P.
www.artbook.com

ISBN 978-3-03778-675-8, English
ISBN 978-3-03778-681-9, French

Printed in the Netherlands

swiss arts council

prohelvetia

The Swiss Arts Council Pro Helvetia is mandated by the Swiss Confederation to promote artistic creation in Switzerland to contribute to cultural exchange at home, promote the dissemination of Swiss culture abroad and foster cultural outreach. It is responsible for Swiss contributions to the several editions of art and architecture biennials in Venice. Switzerland has taken part in the Biennale Arte since 1920 and in the Biennale Architettura since 1991.

Commissioners
Swiss Arts Council Pro Helvetia:
Madeleine Schuppli, Head of Visual Arts
Sandi Paucic, Project Leader
Rachele Giudici Legittimo, Project Manager

Biennials Jury Architecture
Swiss Arts Council Pro Helvetia:
Céline Guibat (jury president, architect EPFL, SIA, Zurich, Sion)
Anna Hohler (architecture critic, UNIL, SIA, Lausanne)
Verena Konrad (architecture curator, Vorarlberg, Austria)
Lukas Meyer (architect ETH, FAS, Bellinzona)
Rob Wilson (architecture writer, The Architects' Journal, London, UK)

Project Collaboration
Swiss Arts Council Pro Helvetia:
Martina Lughi, Anita Magni, Jacqueline Wolf

Press Office Switzerland
Swiss Arts Council Pro Helvetia:
Ines Flammarion, Chantal Hirschi, Lisa Stadler

Press Office International
Pickles PR: Joseph Lamb, Caroline Widmer

PROJECT

17th International Architecture Exhibition – La Biennale di Venezia

Curators and Exhibitors
Fabrice Aragno, Mounir Ayoub, Vanessa Lacaille, Pierre Szczepski

Collaborators
Noémie Allenbach, Benoît Beurret, Jürg Bührer, Annabelle Voisin

Atelier
Raphaël Aragno (intern)
Maxime Bondu (Association Bermuda)
Patrick Buri (Serrurerie des Z'Atelier)
Florimond Dupont
Benjamin Elliott
Eléana Lacaille (intern)
Thierry Payet
Jony Valado
Luca Veuillet

Tour
Aïcha Ayoub
Chems Azim (intern)
Sacha Beraud (website tour)
Agnès Collaud
Hélène Gallezot
Aurèle Gheyselinck
Danielle Fischer
Mathias Lacaille (intern)
Giona Mottura
Olowine Rogg
Workshop Diploma 2020, Accademia di architettura di Mendrisio, Studio Bonnet: Frédéric Bonnet (Professor), Hope Strode (Assistant), Federica Bernardelli, Federico Broggini, Alessandra De Mitri, Maria Minic, Gabriele Tommaso Pace, Elisa Sassi, Benedetta Tacchella, Francesco Vasconi, Marie Pauline Wichard

Mobile Forum
Spring school workshop 2019, Bern University of Applied Sciences: William Fuhrer (Professor), Andreas Bachmann and Jürg Bührer (Scientific Collaborators), Mia Basa, Lena Blank, Carole Bosshard, Luca Bruno, Thomas Kurz, Catia Marques da Cruz, Guido Reichenbach, Meret Stuker, Michael Thierstein, Christian von Känel, Dominic Zeller and Sophie Frank, Arif Sadek, Natascha Beck, Andreas Michel, Stephanie Stöckli

Map
Sabrina Peerally (Atelier de sérigraphie MADAME)
Jean-Paul Trincat (A.D.O Atelier des Ouates)
Moléson Impressions
Pierre Mouchet (Look Graphic SA)

Consultants
Cyril Veillon
Stéphanie Hoareau

Architectural Consultant Pavilion
Alvise Draghi

Pavilion Manager
Tommaso Rava

www.biennials.ch
www.prohelvetia.ch

SPONSORS AND SUPPORT

With the support of
Republic and Canton of Geneva
City of Geneva
Bern University of Applied Sciences
Swisstopo, Federal Office of Topography
Ikea Foundation Switzerland
Loterie Romande

Support Publication
BSA-FAS, Federation of Swiss Architects
Fondation Jan Michalski

Support Mobile Forum
Herzog Bau und Holzbau AG
Blatter AG
Holzbau Schweiz
Fankhauser AG Fahrzeugbau
Blumer Lehmann
OLWO AG
Schilliger Holz
SFS unimarket AG
Bauholz Wenger GmbH
n'H Neue Holzbau AG
Serge Ferrrari AG
HP Gasser AG

Media Partner
Espazium AG